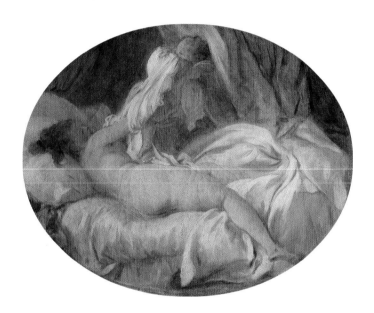

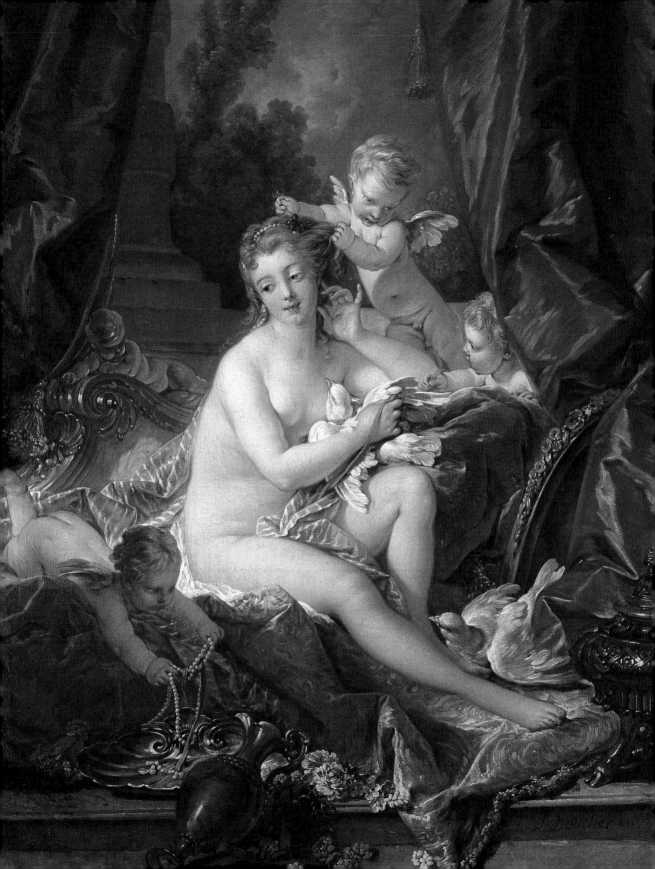

ROCOCO

EVA-GESINE BAUR
INGO F. WALTHER (ED.)

TASCHEN

HONG KONG KÖLN LONDON LOS ANGELES MADRID PARIS TOKYO

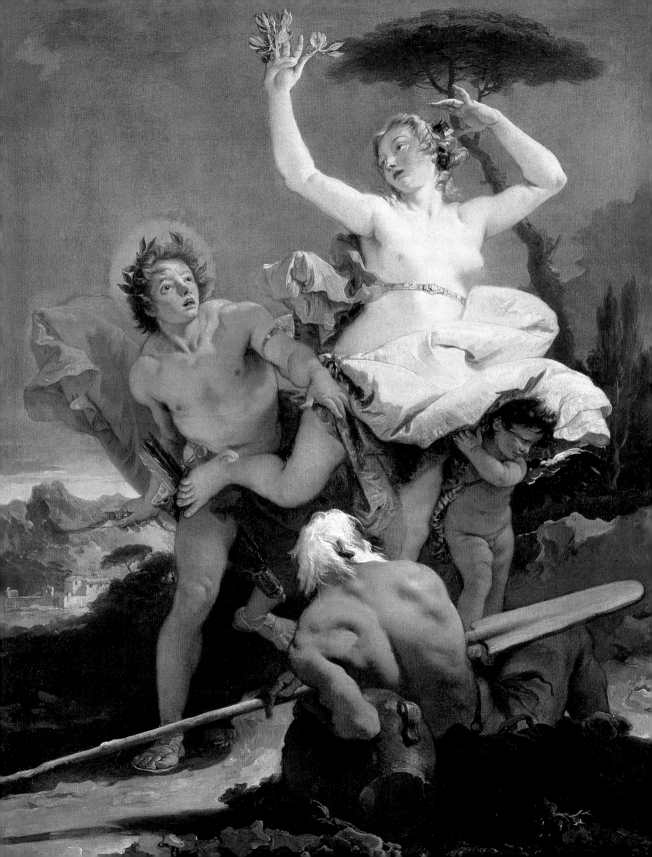

contents

Elegance and idyll in the painting of the 18th century

In Rococo, the sublimity of the Baroque gives way to a more relaxed style of almost whimsical ease. Sentiment and emotion prevail over reason. Yet the "fêtes galantes" and pastoral idyll, the sophisticated elegance and amorous trysts are often little more than theatrical settings, serenely elegiac dreams behind which there lurks an awareness of paradise lost.

The centres of Rococo painting were Paris, Venice and London. In the Parisian art world, "gallant" scenes by Watteau, Boucher and Fragonard predominated, along with the delicate still lifes and genre paintings of Chardin. In Venice, we find the magnificent cityscapes and veduta of Canaletto and Guardi, along with Tiepolo's brilliantly illuminated ceiling frescos. London society celebrated portraitists of stature such as Hogarth, Gainsborough and Reynolds, while in Southern Germany and Austria, pious images of celestial serenity spanned the church ceilings created by Asam and Zimmermann, Troger and Maulbertsch.

In 1874, the brothers Edmond and Jules de Goncourt published the final volume of their joint œuvre *L'art du XVIIIe siècle*. In doing so, they took the first major step towards rehabilitating an era that has undergone a turbulent and constantly changing reception, right up to the present day, and which has so far defied virtually all attempts at elucidation and revival.

The misunderstandings began even before the era had come to an end: a still vibrant epoch was declared defunct, rejected by the very people who were themselves caught up in it and who now protested against a *zeitgeist* of which they were still very much a part. Rococo was carried to its grave amidst the tumult of the French Revolution. Historians cite 1789 as the turning point that heralded its demise, and stress that the "outbreak" of the Revolution was the inevitable culmination of a process that had begun fermenting long before. The actual beginning of that process cannot be pinpointed; it can only be observed as a gradual change of consciousness.

The categorical distinction that tends to be made between Rococo and Neoclassicism has always been one of the major obstacles to understanding the 18th century as a whole. In the 1790s, Parisian artists coined the term "Rococo" from the word "rocaille", and even then it was applied disparagingly. The concept of florid superficiality and complacent serenity that continues to mar our view of Rococo art was already firmly established. In Germany, in particular, the widespread emergence of idyllic poetry, pastoral romance and convivial Anacreontic lyrics – often of mediocre quality – merely strengthened this view. The garlands of roses and bowers of love, the nightingales, whispering zephyrs and blushing Chloes represent only one rather narrow aspect of an era, but one which has tended to be mistaken for the whole story.

1697 — The European rulers imitate the example set by the French court at Versailles. 1700 — The heyday of Delft pottery.

1703 — Work starts on the construction of what will be Buckingham Palace.

> **"As for canaletto his speciality lies in painting vedute of venice. In this genre he surpasses all others."**
>
> Charles de Brosses

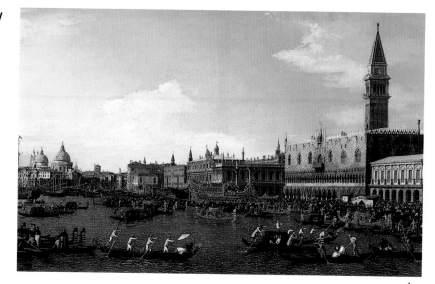

1. CANALETTO

The Bucintoro in Venice
c. 1745–1750, Oil on canvas, 57 x 93 cm
Madrid, Museo Thyssen-Bornemisza

1

Small wonder, then, that the young Germans of the 1830s used the word "Rococo" pejoratively, as a term evoking stuffy courtesy, inflexible convention and an outmoded *ancien régime*. Even in 1859, when Wolfgang Menzel (1798–1873) introduced the term to literary history, it was synonymous with empty and meaningless ornamentation. The aesthetic theorist Friedrich Theodor Vischer (1807–1887) was probably the first to propose adopting it as a term in art history. Used in this context since the 1860s, it has gradually become a neutral term designating a historical epoch.

It is no coincidence that, towards the end of the 19th century, following the Neoclassicist trends of the previous century it was precisely the culture of Rococo that should have been rediscovered by the exponents of Jugendstil (as Art Nouveau was known in Germany), and echoed in the writings of Hugo von Hofmannsthal (1874–1929), Richard Dehmel (1863–1920) or Otto Julius Bierbaum (1865–1910); after all, they perceived an essential kinship in it, with which they could identify. However subjective this interpretation may have been, it nevertheless succeeded in liberating the Rococo era from the stigma of superficiality.

Repression of fear

Apocalyptic fear and identity crises, visions of death and doubts about reality were the underlying factors in which this generation found its affinities with the "fall of the Baroque". Admittedly, there were certain similarities in the way these fears were repressed rather than overcome. Myth and fairytale, festivity and fantasy, theatre and music were called upon to create dream worlds and intermediate realms that would allow all this to be forgotten without losing an awareness of these mechanisms and without giving up reflection on appearance.

If we bear this in mind when we contemplate the "fêtes venitiennes" and masquerades of Francesco Guardi (1712–1793), the concerts of Nicolas Lancrets (1690–1743), the love scenes of Watteau, the simple pleasures of the circus scenes and street scenes of Pietro Longhi (1702–1785), we can grasp an important aspect of their character. The avoidance of shadow is another major characteristic of the new techniques. The white grounding in the works of Jean-Honoré Fragonard (1732–1806), the light pastels of Rosalba Carriera (1675–1757), Maurice Quentin de La Tour (1704–1788) and Jean-Etienne Liotard (1702–1789), or the shallow sheen of porcelain figures in the work of Franz Anton Bustelli (1723–1763) are as symptomatic of this era as the fashion for powdered wigs. The "Ile enchantée" or en-

1704 — Antoine Galland translates and publishes the collection of Arabic fairy-tales known as the "1001 Nights".
1705 — Large factories are set up especially in new industrial sectors such as wallpaper, tobacco and textiles.

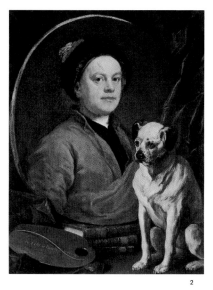

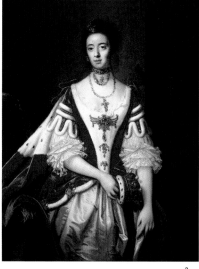

2

3

chanted island became a vehicle for the projection of a dream of care-free timelessness; it appears as *Cythera* in the work of Watteau or remains nameless in the work of Guardi, who painted a series of twenty-one islands. Venice attracted artists and travellers. The foreign and the exotic became the focus of a new view of life, "Russeries", "Chinoiseries" and "Japanoiseries" became treasure troves of disguise.

Detachment as a pictorial device

At the same time, the ironic detachment and self-consciousness of the Rococo age became evident in the deliberate use, application and exploitation of all things foreign or different in terms of phenomena that are beyond understanding. A spirit of enlightened detachment underpins a wide variety of forms of expression. We find it in the synopsis of the "veduta ideata", the panoramic paintings of Canaletto (1697–1768) and Bernardo Bellotto (1721–1780) and it forms the basis for the art criticism of Denis Diderot (1713–1784) as well as providing fertile soil for the art of caricature which was to blossom in England especially.

Detachment is also a fundamental aspect of the one field that has been most vehemently criticized as superficial and frivolous: eroti-

cism. Giacomo Casanova (1725–1798), the figure who, more than any other, is popularly regarded as epitomizing the spirit of the era, reports in his memoirs of an experience that made him keenly aware of his own vanity. Having dismissed as prudish a girl who had resisted all his seductive wiles, he observed her one night with someone else, doing exactly what he had being trying to inspire her to do when he had shown her the engravings of Giulio Romano (c. 1499–1546).

Indirect or ironic deflection is another important factor that played a major role in shaping the portrait – surely the greatest achievement of 18th-century art. In the self-portrait of William Hogarth (1697–1764) the artist makes a merciless comparison with the dog whose physiognomy seems distinctly similar to his own (ill. p. 8). In the self-portait of La Tour, we find an arrogant and thin-lipped smile and a pose that denies all claims to beauty (ill. p. 55). Jean-Antoine Houdon's (1741–1828) sculpture of Voltaire (1694–1778) shows the great scholar as a man past his prime, cynical, balding and without a wig. Portraits depict their sitters in dressing gown or negligée, with a candour that is less than flattering. Such tongue-in-cheek revelation harbours a witty and critical balance of truth and untruth, semblance and reality.

Atttitudes to nature and landscape were similarly oblique. The landscaped gardens of Capability Brown (1715–1783) were designed

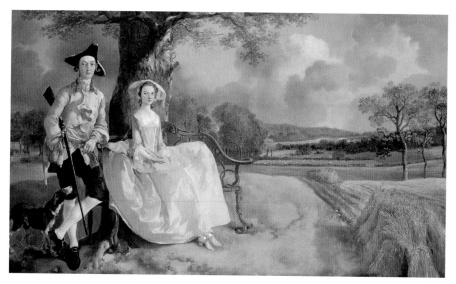

4

to look natural, full of "chance" effects that had been precisely calculated and the "belt walk" was intended to guide the walker along a route revealing the garden's precalculated surprises to greatest visual effect. Thomas Gainsborough's (1727–1788) landed gentry (ill. p. 9) are no more bound to the nature or landscape in which they are portrayed than Queen Marie Antoinette (1755–1793) was a milkmaid in her make-believe village of the Trianon at Versailles. While the role portrait or "portrait historié" by Joshua Reynold (1732–1792) emphasizes the boundary between play and identity, it does not do so brashly, but in the discreetly subdued tones of a secret, a slip, an unintentional betrayal of one's true self (ill. p. 8).

The art of cultivating and addressing the question of superficial appearances achieves its greatest concentration and complexity in Rococo. The "rocaille" from which the era takes its name is both figurative and non-figurative. With its florid curves of coral, shell and plant, it forgoes all symmetry, axis and hierarchy, yet subjects itself at the same time to planarity and space. It is both artistically crafted and amorphous at one and the same time.

The dissolution of contour

The dissolution of contour is a central concept in the formal rules and subject matter of painting. The German poet and man of letters Christoph Martin Wieland (1733–1813) once wrote, in a letter, of his epic fragment *Idris and Zenide*: "Imagine a fable after the manner of *Quatre Facardins* or the *Bélier* by Hamilton – but a fable unlike any other, one born of a healthy mind – the quintessence of all the adventures of Amadís and of all fairytales. And in this plan, under this frivolous exterior, metaphysics, morality, the most secret machinations of the human heart, criticism, satire, characters, paintings, passions, reflections, sentiments – in short, all you could wish for, with enchantments, ghosts, duels, centaurs, gorgons beautifully penned and mixed together, and all in such variety of styles, so lightly painted, so lightly versified, so playfully rhymed – and in *ottava rime* at that." In the field of literary studies, Alfred Anger noted a phenomenon of considerable importance to art history when he spoke of the "dissolution of borders between genres": The blending and merging of forms, materials, different levels of reality, quotes and costumes (the classical Italian poetic form of *ottava rime* is to be regarded in this light).

The unhierarchical approach of Rococo merges the figure of the mistress with the figure of Venus, and combines characters from pagan

1709 — The first excavations at the foot of Mt. Vesuvius uncover the remains of the towns of Pompeii and Herculaneum, which were buried under ash in the eruption of 79 CE. **1712 — The newly founded city of St. Petersburg becomes the Russian capital.**

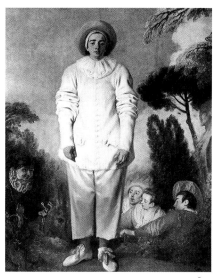

5

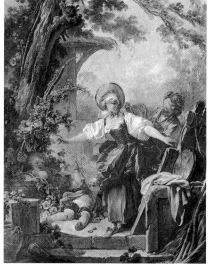

6

5. JEAN-ANTOINE WATTEAU

Gilles
1721, Oil on canvas, 184 x 149 cm
Paris, Musée National du Louvre

6. JEAN-HONORÉ FRAGONARD

Blind Man's Buff
c. 1760, Oil on canvas, 114 x 90 cm
Toledo (Ohio), The Toledo Museum of Art

7. HUBERT ROBERT

The Tempel of Diana in Nîmes
1783, Oil on canvas, 101 x 143 cm
Madrid, Museo Thyssen-Bornemisza

mythology with utter disregard for rank or status. It brings together the tragic and the satirical in Hogarth's *Mariage à la Mode* or *The Harlot's Progress*, and presents a naively earnest child in Reynolds' painting of *The Infant Samuel* (ill. p. 81), while Watteau's harlequins, Gilles and Pulcinella combine elements of the comic and the tragic (ill. p. 10). Play and reality are as indistinguishable in Fragonard's *Blind Man's Buff* (ill. p. 10) as theatre and real life, mythology and eroticism, vision and episode are in the works of Watteau, François Boucher (1703–1770) or Alessandro Magnasco (1677–1749).

In the paintings by Hubert Roberts (1733–1808) architectural ruins, street scenes, staffage and actual observations all become part of a vivaciously staged reality (ill. p. 11). Indeed, long before the French Revolution, we find categorical social boundaries disintegrating with the emergence of a new and self-confident bourgeoisie, evident in such paintings as Hogarth's *The Graham Children* (ill. p. 46).

What is more, we find an affinity for simplicity and rural life prevailing over sentimentality, especially in England. In Lawrence Sterne's (1713–1768) *A Sentimental Journey through France and Italy* (1768) sympathy for spiritual and material poverty is more than just a means of exploring one's own sentiments; it is also imbued with a sense of that utopian yearning which sought tranquility in intellectual or material deprivation.

The very fact that Samuel Richardson (1689–1761) and his countless imitators presented servant girls as the heroines of their literature would also indicate a tendency to project their own concepts of happiness onto what they considered a "natural" and unspoilt environment, as in the "fancy pictures" of such artists as Gainsborough. Social hierarchies were being dissolved in an attempt to enter previously inaccessible lifestyles, where artists and writers imagined they would find some kind of Arcadian existence. The same approach also permitted a complex fragmentation of the Baroque system of order, opening up a wealth of possibilities by which to heighten the depiction of highly contrasting interests.

The rigours of ceremonious rules and regulations fuel the mordant satire of Hogarth's *Shortly after the Mariage* (ill. p. 12), and indeed, the very existence of such rules and an awareness of them is fundamental to the sense of revelation in such paintings. Surveillance merely heightens the appeal of the clandestine: in Fragonard's *The Swing* (ill. p. 71) the presence of the foolish and elderly man stimulates the couple's erotic excitement. Occasionally, moral censorship was cloaked in pathos-laden sentimentality, a device so patently obvious in the paintings of Jean-Baptiste Greuze (1725–1805) that it simply adds further piquancy to the eroticism of his motifs (ill. p. 75). The social conventions of portraiture bring out the childlike qualities of

1714 — Gabriel Daniel Fahrenheit develops the mercury thermometer with the scale named after him.
1715 — Death of the French "Sun King" Louis XIV.

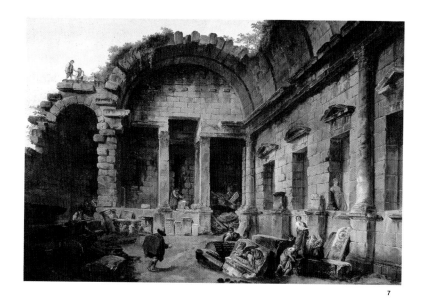

7

the sitters in the portraits of children by Reynolds or Hogarth. Finally, the breakdown of inflexible systems also signifies the dissolution of Baroque typology, paving the ground for one of the greatest achievements of 18th-century painting: the portrait.

The images of life observed

The effects of a changing and enlightened consciousness are evident in the impartial observation and representation of the unique individual. A phenomenon such as the English animal portrait, odd as it may seem to us today, should certainly be considered in this context (ill. p. 14). In a painting by George Stubbs (1724–1806) a poodle is not simply a poodle, but an individual creature capable of specific and unique feelings. This cultivation of individuality is at the same time a cultivation of the very factors Jane Austen (1775–1817) addressed in the title of one of her novels: *Sense and Sensibility* (1811).

The astute and unprejudiced eye of Hogarth and, most notably, Francisco José de Goya (1746–1828), spawned very different forms of expression. Goya's unflattering group portrait of *The Family of Charles IV* (ill. p. 13) and his individual portraits of various members of Spanish royalty are fine examples of this neutral observation and a keen

awareness of forms and conventions which have lost their significance. It was Goya's rigorous rejection of meaningless forms already devoid of all credibility that imbued his works with the pathos and monumentality of truth. This is undoubtedly Goya's greatest pioneering achievement and the reason for his profound influence on the art of the 19th and even 20th centuries. In the privacy of his isolated and modestly furnished home, he dared to express the extreme consequences of his clarity of vision in his paintings; in the *Quinta del Sordo*, apocalyptic visions become reality, Saturn devours his children, an abandoned dog drowns in the sand dunes. Henry Fuseli's (1741–1825) *The Nightmare* undoubtedly stems from the same new concept of reality, in which dream, fantasy, foreboding and psychological phenomena are very real elements.

Art criticism as the product of a new public

It was not until the 18th century that art criticism as we know it emerged. When it did, it went hand in hand with the advent of the art exhibition and, with that, the rise of a new desire for publicity and a new understanding of art reception. Although there had already been a "salon" – an annual exhibition organized by the king – as early as

1715 — Starting in England, the idea of the "natural" landscape garden spreads across Europe.

1717 — The Freemasonry movement begins with the foundation of the first Grand Lodge in London.

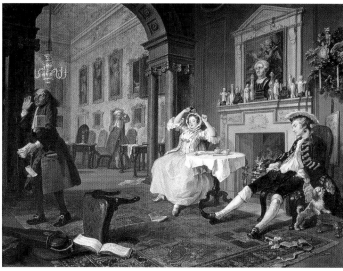

8. WILLIAM HOGARTH

<u>Mariage à la Mode: Shortly after the Marriage</u>
c. 1743, Oil on canvas, 69,9 x 90,8 cm
London, The National Gallery

9. FRANCISCO JOSÉ DE GOYA

<u>The Family of Charles IV</u>
1800/01, Oil on canvas, 280 x 336 cm
Madrid, Museo Nacional del Prado

8

1667, this had taken place in the open air in the courtyard of the Palais Royal. In 1699 it was held in the Louvre, though not on a regular basis (ten times in all during the reign of Louis XIV). Eventually, in 1737, the Salon became a firmly established part of French artistic life and an important meeting place for artists and the public. The involvement of a wider public soon made its mark. Parisian society took every opportunity of voicing opinions, often vehemently, with regard to the exhibits, and of influencing the choice of exhibits in this way. Soon, a number of writers, journalists, philosophers and laypersons were publishing their opinions at every level in a wide variety of periodicals. The art critic had arrived on the scene.

Art criticism actually began with non-criticism. From the 1720s onwards, the *Mercure de France* occasionally published reports on exhibitions, consisting of little more than emphatic and uninformative eulogies of praise for the artists and their works. The desire for genuine criticism was voiced in a text published in 1747 by Lafont de Saint-Yenne entitled *Réflexions sur quelques causes de l'état présent de la peinture en France* in which he formulated the right to criticism as follows: "A painting exhibited is like a printed book, or a staged play – everyone has the right to judge it." Although Lafont claimed to regard common sense as the essential criterion of judgement, he nevertheless followed the dogma of academicism, as all the art publishers of the era

were to do in his wake. Implacable in his criticism of Rococo painting, Lafont nevertheless couched his criticism in terms that reflected a profound change of attitude: he railed against what he saw as its inherent lack of force, its inauthenticity and its faddish triviality.

Though the artists themselves, most notably Charles-Antoine Coypel (1694–1752) defended themselves vigorously against this kind of opinion-formation, art criticism managed to esconce itself firmly in the role of arbitrator. Charles Montesquieu (1689–1755), Jean Baptiste d'Alembert (1717–1783), Voltaire, Jean-Francois Marmontel (1723–1799) and the Marquis d'Argens (1704–1771) and with them virtually all the leading literary figures and philosophers of the day penned their opinions on the subject of art, helping it to become a recognized and independently esteemed profession. Their writings were counterpointed by an equally prolific outpouring of popular and satirical brochures publishing criticism of a generally low standard.

It was also the art critics who drew up and evaluated the categories; Friedrich Melchior Baron von Grimm (1723–1807), who published his *Correspondances littéraire, philosophique et critique* from 1753 onwards, distinguished between the "poetic" and the "painterly", disparaging the former as art driven by the unfettered powers of the imagination and recommending the latter as art driven by the grand passions and emotions of the soul. Instead of the "happy moment" that

1719 — Daniel Defoe writes the adventure novel "Robinson Crusoe".

1727 — By the 1780s, some 2 million Africans will be shipped as slaves to America.

> "The serpentine line, or line of grace, by its waving and winding at the same time different ways, leads the eye in a pleasing manner along the continuity of its variety."
>
> William Hogarth

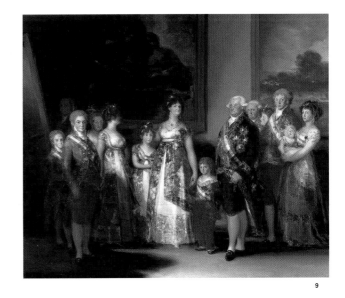

9

Fragonard, Boucher and Nicolas Lancret had sought to capture, artists were now called upon to portray the great and significant moment (ill. p. 10). The key concepts of the new style were "nature" and "truth" – terms which, in themselves, shed some light on the intellectual climate of the day.

what is "nature"?

In the monumental 19th-century dictionary compiled by the German scholars J. and W. Grimm, nature is defined as "expression", meaning the expression of high civilization and sublimity of character. This is very much the same concept of nature that informed the extremely positive attitudes to sculpture reflected in the writings of Diderot and Voltaire; sculpture was regarded as an art with a "natural" affinity to classical antiquity. The stamp of Neoclassicism is evident in those aspects which the art critics of the day regarded as representative of the spirit of antiquity – in the works of Jean-Baptiste Pigalle (1724–1785), François Girardon (1628–1715), Etienne-Maurice Falconet (1716–1791) and Pierre Philippe Mignot (1715–1770).

Even though Diderot, who was probably the most important art critic of the 18th century, never abandoned the notion that art should

imitate nature and the belief that the study of ancient Greek and Roman art taught us to see nature, this had little in common with the theory of imitation propagated by Johann Joachim Winckelmann (1717–1768). In 1755, Winckelmann published his *Gedanken über die Nachahmung der Griechischen Wercke in der Malerei und Bildhauerkunst* (Reflections on the imitation of Greek works in painting and sculpture) to considerable acclaim throughout Europe. In it, the portrayal of truth and the nature of things is already posited as the basis of artistic creativity, but interpreted in a rather different way. Winckelmann saw expression – especially "violent passion" or excitement – as a hindrance. "The soul is more evident and significant in a state of violent passion, but it is great and noble in the state of oneness and peace."

The extreme consequences of these programmatic theses are to be found, for example, in England. Though the author himself warned against unreflected imitation, believing that "ideal beauty" could only be found by "overcoming naturalism", he was frequently misconstrued. His emphasis on the primacy of drawing and the importance of contour was at the same time qualified by a warning: "Those who sought to avoid emaciated contour have succumbed to bombast; those who sought to avoid the bombastic have succumbed to leanness." The outline drawings of mythological scenes by John Flaxman (1755–1826) are a clear example of such "leanness".

1729 — With the help of telescope observations, the first star atlas is compiled, showing 2866 stars

1734 — The "Great Nordic Expedition", including explorers from Russia, Germany and France, sets off for the Arctic.

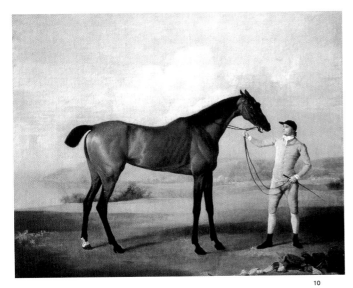

10. GEORGES STUBBS

<u>"Molly Longlegs" with Jockey</u>
c. 1761/62, Oil on canvas, 102 x 127 cm
Liverpool, Walker Art Gallery

11. JOHN SINGLETON COPLEY

<u>The Death of Major Peirson</u>
c. 1782–1784, Oil on canvas, 247 x 366 cm
London, Tate Gallery

10

The enhancement of the marginal is also a crucial stylistic change. This is evident in the fact that Ramon Bayeu y Subías (1746–1793; ill. pp. 86, 87) and, during a certain phase, Goya, presented harsh and clearly contoured figures against a monochromatic background. It is also evident in the ceiling paintings of southern Germany, where centred Baroque compositions were occasionally enriched and sometimes even ousted by a border area running parallel to the edges of the painting. The fact that this border area represents landscape is also an indication of a decisive change, heralding the end of the illusion of spatial extension created in the Baroque era by means of *trompe l'œil* architecture. The picture becomes a picture again. Seen in this way, the transcendental aspect of blurred borders and broken boundaries actually ends with Rococo, though in other areas it shapes the style of an epoch.

what is truth?

The second central tenet of French art criticism is the concept of truth. Critics praised the truth of Greuze (ill. p. 16), referring to the intensity of feelings he evoked. Emotion as an experience of one's own capacity for empathy and sympathy was the most recent form of prov-

ing existence and was therefore regarded as "true". The same phenomenon could also be found in England, with the appearance of Sterne's *Sentimental Journey* or Richardson's servant maids in the world of literature, while the portraiture of George Romney (1734–1802; ill. p. 17), John Opie (1761–1807) and Henry Raeburn (1756–1832) was both sentimental and stiffly Neoclassical. Truth was also lauded in the works of Vernet, Jean-Baptiste Oudry (1686–1755; ill. p. 18) and Jean-Baptiste Siméon Chardin (1699–1779) – in those cases, in the sense of clarity and simplicity. In the work of Vernet, Diderot discerned an affinity with the much-admired Lorrain in terms of the similarity of pictorial composition – a misunderstanding that completely overlooks the compilatory technique used by Vernet in composing his landscapes out of cited individual motifs. If we consider the still lifes of Oudry and Chardin, it is easier to understand what prompted critics to describe them as "true": Their truth lies primarily in the reduction to a few generally simple pictorial objects, but also in the clarity of composition and the restraint of pictorial technique.

Chardin's *Still-Life with Basket of Strawberries* (ill. p. 19) is a brilliant condensation of all these qualities. The pyramid of identical berries in a basket – presented to the spectator with neither ornament nor decoration – is monumental in its simplicity. The tranquility of the image thrives on its inherent significance; there are no allegorical ref-

1736 — Birth of the Scottish inventor James Watt. 1741 — Foundation of the Burgtheater in Vienna.
1745 — The Marquise de Pompadour becomes the mistress of Louis XV.

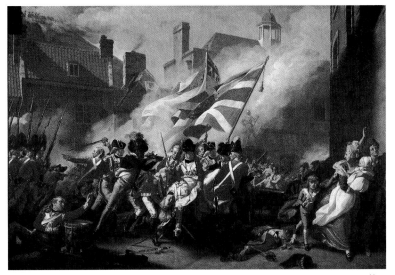

11

erences to that which is shown, beyond the confines of the painting itself. No stimulating light whose source must be sought, no enigmatic pictorial meaning puzzles the spectator. Neither the objects portrayed nor the picture as a whole seek to be anything more than they appear to be. It is this that makes the concept of truth appear justified in contemplating this work.

English concepts of reality

If art criticism played a much less important role in 18th-century England, this is because the polarity of academicism versus non-academicism never reached such heights as it did in France. The change of style demanded by both the public and the critics did not come about suddenly in England, but in the form of a gradual development emanating from the work of individual artists. Nevertheless, the issue of truth was also discussed here – not in theory, nor in the aesthetics of reception, but in the work of many artists. It is not the critical form of a change of epoch, but the logical consequence of the observation of social and spiritual or psychological processes.

At the very beginning of the "golden century" of English painting, we find, in Hogarth, an artist unfettered by academic rules, bound by no specific school, whose strong sense of individuality gave him the liberty of an impartial eye. The truth in the work of Hogarth resides primarily in the idiosyncracy of his style, in his unpretentious attitude that invariably puts all representational needs second to the faithful reproduction of what he has seen. In his series of prints *A Rake's Progress*, *A Harlot's Progress* and *Mariage à la Mode* he reveals the hypocrisy and insincerity of social mores and the cruelty of social obligations. In many of his paintings, he stresses the importance of the wig, satirically emphasizing its status as a ridiculous symbol of power used by ageing and indifferent judges, by dandies and complacent gentry, or showing a wig that has slipped from the balding head of some drunken gallant, set aside wearily, or deliberately removed, recalling the rake in his cycle *A Rake's Progress*, who appears in the end as a bald and repulsive madman. This is scathing criticism indeed. It has nothing whatsoever in common with the coquettish "déshabille" of French society revealed in the paintings of Boucher or Jean-Marc Nattier (1685–1766). It is a mordant revelation tempered only by a distinctly English talent for bringing out the comic side of things.

The rough-and-ready caricatures by Thomas Rowlandson (1756–1827), George Cruikshank (1792–1878) and James Gillray (1757–1815) may also be included in this category, as expressions of a quest for truth that is not moral and theoretical but observational.

1748 — The French thinker Montesquieu develops a theory of the state based on the "separation of powers".

1751 — The first of a total of 35 volumes of the French "Encyclopédie" are published by Denis Diderot.

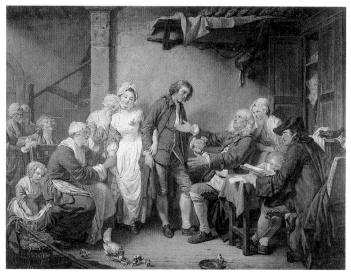

12. JEAN-BAPTISTE GREUZE

<u>The Village Betrothal</u>
1761, Oil on canvas, 90 x 118 cm
Paris, Musée National du Louvre

13. GEORGE ROMNEY

<u>The Leigh Family</u>
c. 1767–1769, Oil on canvas, 180 x 197.5 cm
Melbourne, National Gallery of Victoria

12

When Fuseli, for example, portrays scenes drawn from the depths of the unconscious, as in his *Nightmare* (Frankfurt am Main, Goethe Museum), he is working in the same tradition of art that shakes off the categories of aesthetic tradition and reproduction of reality in order to present the truth.

The greatest and most terrifying examples of an almost obsessive quest for truth can be found in the works of Goya. Not only in his portraits – including the Spanish royal family – but also, most notably, in his series of prints *Caprichos*, *Disparates*, the bull-fighting scenes of his *Tauromachia*, the *Proverbios* and the *Desastres de la guerra*. The brutality of the Inquisition, the horrors of the Napoleonic wars, the cruelty of ancient rites are not objective reports of injustice observed or experienced, but depictions that overstep the bounds of specific, cynical social criticism, lighting the path of a self-destructive obsession that drives him to look, see and understand. Truth no longer appears in the guise of allegory or mythology. It is neither noble nor fine, but merely inescapable.

Goya heightens this statement by foregoing the aesthetic escapism of beautiful colours in favour of black and white printing techniques such as etching, aquatint and even lithography – some of which were recent developments. The 18th century spawned an unprecedented pluralism of artistic techniques that were to shape the face of the era. The height of Rococo coincided with a rediscovery of camaieu and grisaille painting as techniques appropriate to the subject matter they conveyed. By constructing a monochromatic image – generally in grey or brown – there can be no pretence of reproducing reality. The picture can be regarded as a picture, emphasizing its artificiality as a medium and creating an artificial world governed by its own laws. What is more, the bounds of reality in the painting itself can be dissolved, and various levels of reality can merge with the irreality of monochromatic worlds.

rococo pastels

One of the most characteristic features of the era is its love of pastel. This is a technique that first emerged in 15th-century Italy. Yet although there are chalk drawings by Leonardo, Holbein, Philippe de Champaigne, Wallerant Vaillant (1623–1677) and many others, the technique first found real popularity with the artist often erroneously cited as its "inventor", Rosalba Carriera. Three aspects of her art and the genesis of her style are of importance to the development of pastel. First of all, there is her amateur approach: Rosalba, the daughter of an impoverished wood merchant, received second-rate training in her

1752 — The minuet is the favourite dance of courtly society. 1755 — Lisbon is destroyed by a major earthquake.
1759 — Foundation of the British Museum in London, created from private collections.

"The magnitude of our social problems will require that all citizens and institutions make a commitment to volunteering as a way of life and as a primary opportunity to create needed change."

George Romney

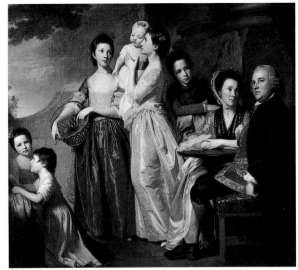

13

home town of Venice from Giovanni Antonio Lazzari (1639–1713), a student of Bassano, who recommended that she use coloured chalks for drawing. For the most part, however, she was self-taught. As her highly informative diaries tell us, she regarded herself as a successful amateur rather than a talented professional.

Nevertheless. she soon became one of Europe's most sought-after portraitists, representing fashionable taste. Because the use of pastel does not require a high degree of technical skill, drawing with coloured chalks of bound pigment on vellum or coloured paper soon found favour amongst amateur artists. The blurring of contours with a pointed roll of paper known as a "tortillon" or "stump", the ease with which corrections and alterations could be made, the "clean" working technique that required no palette, not to mention the pleasing results of even the most unambitious works, made pastel a highly popular technique, particularly in England. What is more, it fitted in well with prevailing notions of what constituted a "suitable pastime for ladies".

A further typical feature of the paintings by Carriera indicates her grounding in miniature painting. The small detail and cumulative approach involved in this genre lend it a certain affinity to pastel techniques. The great pastellist Liotard, for example, also began as a miniaturist. The rigidity of Carriera's pastels, so often a point of criticism, is also an essential feature of her work. In spite of the sfumato

and the dissolution of sharp contours that appeal to Rococo taste, they possess a singular immobility that was perhaps first overcome by La Tour and which at the same time paves the way for the Neoclassicist pastel techniques in the works of Johann Heinrich Wilhelm Tischbein (1751–1829) and Angelica Kauffmann (1741–1807).

In 1720/21 Rosalba Carriera was in Paris, where she had a seminal influence on the great French pastellists. The cool discretion of pastels, reflecting the intimacy of the boudoir rather than any overweening pretensions, made the technique very appealing to French artists. Different talents were drawn to the possibilities offered by pastels.

La Tour, the most important pastellist of all, favoured a bluish background which created a sense of distance right from the start and which, as in his self-portraits, harmonized with the irony inherent in his treatment of his subject matter. For characterization, he also used the rapid technique of superimposing layers of strokes without actually mixing the colours. A bold red stroke over a matt blue ground, a portrait such as that of La Tour's mistress, the singer *Mademoiselle Fel* (ill. p. 20) – these are the new and brilliant forms of portaiture that trace individual identity in the ephemeral.

Jean-Baptiste Perroneau (1715–1785), La Tour's rival for public favour, demonstrated in his works the heights that could be

1762 — Catharine II, known as "the Great", starts to rule as Tsarina of Russia. 1762 — J. J. Rousseau publishes his novel on education, "Émile". 1763 — Paris stages the first trade fair.

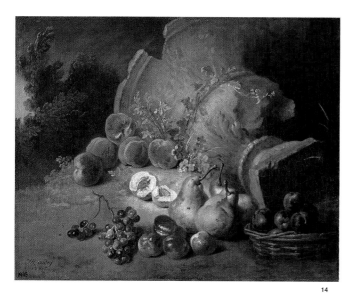

14

achieved with this technique. Using a pale ground, a matt luminosity dominates the colours. Perronau was a master of the art of creating an entire picture on the basis of only a few colours, sometimes no more than two. Foregoing all brash effects and directness in his quest for finesse, delicacy and restraint, his pastels are marked by a distanced artificiality.

Liotard, on the other hand, emphasized colority (ill. p. 20). Apart from a number of pale, light-coloured works dominated by shades of white, we also find in his œuvre some "folkloric" Turkish scenes and portraits in which a strong and richly contrasted colority is created by adding extra pigmentation to the chalks. He, too, bans shadow from his works. Pastels are never gloomy, never non-commital. They brook neither the absolute nor the abrupt. It is for this reason that pastels blossomed in the Rococo age.

capriccio – caprice – capricho

In 1617, Callot published a series of prints entitled *Capricci* which already bore the hallmarks of what was to become an accepted genre known as the "Capriccio". The series had a cover sheet followed by relatively small-scale prints showing strongly improvised scenes with no programmatic link and moving from one subject matter to the next without any apparent system of order.

The provenance of the term "capriccio" has never been satisfactorily explained, though it is generally accepted that it may be derived from "capra" (goat) in reference to that creature's moodiness and mind of its own. Vasari used the adjective "capriccioso" to mean idiosyncratic, witty, breaking the rules. Montana and Stefano della Bella (1610–1664) transposed the capriccio style into ornamental sequences in the 17th century and in the field of copper engravings of ornamental patterns, it developed into the rocaille that was a hallmark of Rococo in the 18th century.

Around mid-century, François Cuvilliés the Elder (1695–1768) published his *Morceaux de Caprices à divers usage* showing rocaille in all its versatility – as a frame, a decorative device, an ornament in furnishings, and even as the subject matter of a painting. At the beginning of this chapter, the dissolution of contours in the broadest sense was presented as a feature of Rococo art. This is clearly demonstrated in the case of rocaille, which unites such elements as corals, shells, sails, smoke or foliage without actually adopting any one of these definitively as its predominant motif. It transcends borders between image and frame, between architecture and image, spanning planes without filling them, yet at the same time acting as an ornamental

1768 — James Cook undertakes a number of voyages to explore Australia, New Zealand, the South Seas and Alaska.
1769 — Napoleon Bonaparte is born in Corsica. **1770** — The start of the "Industrial Revolution".

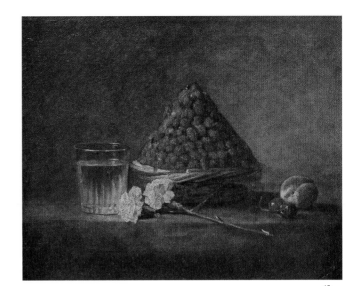

14. JEAN-BAPTISTE OUDRY
<u>Still-Life with Fruit and Stoneware Vase</u>
1721, Oil on canvas, 74 x 92 cm
St. Petersburg, Eremitage

15. JEAN-BAPTISTE-SIMÉON CHARDIN
<u>Still-Life with Basket of Strawberries</u>
c. 1760/61, Oil on canvas, 37 x 45 cm
Paris, Privatbesitz

15

subject matter or as the hidden principle of inherent movement within the picture.

In 1749, Giovanni Battista Tiepolo (1696–1770) created a series of etchings entitled *Varii Capricci* (1749) teeming with the characters which make the capriccio the very epitome of imaginative form: warriors, orientals, satyrs and shepherds, travelling people and all manner of animals, elements from antiquity and exotic objects; all become instruments by which to express a rich imagination. Another approach can be found in the work of his son Giovanni Domenicho (1727–1804) whose *Idee pittoresche sopra La Fuga in Egitto* created in 1753 blends the irreal magic of the capriccio with elements of the Flight into Eypt, resulting in wondrously tender fairytale scenes.

The *Carceri* by Giovanni Battista Piranesi (1720–1778), first published in 1745 under the title *Invenzioni Caprici di Carceri* are widely regarded as the artistic manifestation of an anti-Rococo movement within the Rococo age. Their capriccio-like character marks them as an art form of that era in much the same way as Piranesi's *Opere varie di Architettura* (1750), albeit of a rather different kind: specific architectural elements are condensed to create a labyrinth which no longer seeks to represent specific architecture, but which, in its figurative irreality, confirms the reality of the associations it triggers. Here, the capriccio is a means of uniting objects which have been removed

from their original context. Unlike the Neoclassical approach, which unites such objects in a mosaic-like staffage, the capriccio merges them to create a new entity whose structural principles are based on the artist's own creative fantasy and imagination.

If we interpret the concept of the capriccio a little more broadly, we may include the paintings of architectural ruins, a genre represented primarily by Giovanni Paolo Pannini (c. 1691/92–1765) and his student Hubert Robert, known as "Robert des ruines". In these works, ancient architectural fragments have yet to be incorporated with the same considered stylistic awareness that is evident in the landscaped gardens of the Romantic and Neoclassicist age. Nor do they act as individual vehicles for atmosphere and mood, as in the works of Wilson, Hackert or Vernet. Their appearance of decay is by no means intended as a symbol akin to the Baroque allegories on the transience of all earthly life. Instead, the ruins are perceived as objects whose imperfection permits the associative imagination of each individual observer a free rein. Their crumbling decay contradicts Baroque systems and represents a potential stage for vital events. In terms of this interpretation, Magnasco's night scenes may be regarded as having the character of a capriccio (ill. p. 22).

It is, however, the island series by Guardi which gives the clearest indication of the close thematic relationship between the capriccio

1775 — Outbreak of the American War of Independence against Britain.
1776 — Abolition of torture in Austria-Hungary. **1780 — Death of Empress Maria Theresia, ruler of Austria-Hungary since 1740.**

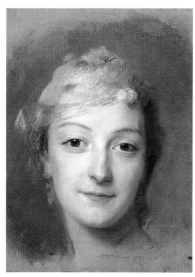

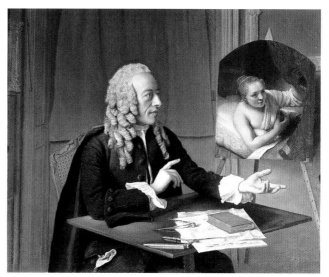

16

17

and the "Île enchantée" (ill. p. 23). Its rejection of inner pictorial logic and programmatic concepts echoes the detachment of the island from the mainland; the private subjectivity of visual creation corresponds to the intimate bounds of an island. In the boundlessness of the subjective imagination, the individual discovers his or her own submerged golden isle or "vineta".

It is here that the "fêtes galantes" provide an alternative means of escape from apocalyptic fears. Perhaps we ought to regard a painting such as Goya's *Burial of the Sardine* (ill. p. 93) as the drastic culmination of these festive visions, transporting us away from reality: the celebration of love has disintegrated into an apocalyptic spectacle.

Fragmentation and invention

In much the same way, Goya's *Caprichos* (1793–1798) marked the end of the capriccio as a field of serene enchantment, as an island removed from all bounds of reality, and as a field of subjective experience. Goya seems to use the capriccio to some extent as a thematic vehicle that allows him to ignore all prevailing rules of form and content. Yet the non-commital stance of the imagination is no longer in evidence. Visions of winged monsters, distorted physiognomies, surreal figures that are half human, half animal, sinister gnomes, masked falsehood, cruelty and destruction are likenesses, and the nightmares he portrays are reality. The beautiful witch bears a distinct resemblance to the Duchess of Alba, the bestial spirits are dressed in monks' habits, the hypocritical opportunists are wearing contemporary courtly dress; the adultress has the traits of a princess featured in his portrait of the royal family, the victims of horrific torture by the Inquisition are portrayed with all the lifelike precision of a "genre" painting; the woman sentenced to death, having taken a lover because she was so maltreated by her husband, is based on an actual lawsuit. Goya makes it absolutely impossible for the observer to escape the reality of the seemingly unreal; he does not allow us to close our eyes to the fact that the supposedly imaginary is true in more than just an abstract sense.

The captions function in the same way. They are generally literary quotations or proverbs, often in seeming contradiction to that which is portrayed: a witch appearing before two sorcerers bears the title *Pious Confession* – enigmatic as they may seem at first glance, they are invariably unequivocal if regarded within the social, political or literary context from which they are taken. No hermetic or mysterious knowledge bears the key to these works – the quotations and proverbs Goya cites were, after all, widely known. In his *Caprichos*, Goya proves

1781 — Immanuel Kant presents his rationalist epistemology in the "Critique of Pure Reason".

1783 — The Montgolfier brothers launch the first hot-air balloons.

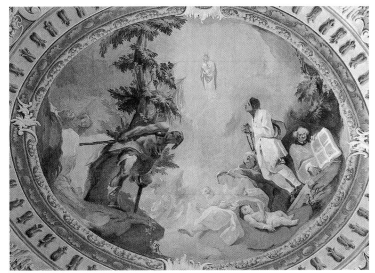

16. MAURICE QUENTIN DE LA TOUR
Portrait of Marie Fel
1757, Pastel on paper, 32 x 24 cm
Saint-Quentin, Musée Antoine Lecuyer

17. JEAN-ETIENNE LIOTARD
Portrait of François Tronchin
1757, Pastel on parchment, 37.5 x 46 cm
Geneva, André Givaudon collection

18. FRANZ ANTON MAULBERTSCH
Adoration of the Virgin
1757, Ceiling fresco (detail)
Heiligenkreuz-Guttenbrunn, organ choir

18

his revolutionary discovery that the true underlying reality can be conveyed more strongly by abandoning a superficial portrayal of reality. He knows that imitating the appearance of things actually conceals their true essence. He knows that similarity breeds dissimilarity. Much of 20th-century art, most notably the works of James Ensor (1860–1949) and Francis Bacon (1909–1992) cannot be fully understood without an awareness of this aspect of Goya's achievement.

The uncompromising radicality of Goya's approach still contains vestiges of the debate on "truth" and "reality" that dominated the 18th century. Truth and reality can take shape even in their opposites. Truth and reality are the content of the illusion. This is evident in that most illusionary of all illusions: the stage.

Theatre and illusion

Around 1700, winds of change swept the world of stage design. The changes that took place are inextricably linked with the Galli Bibiena family, whose most famous representatives were Giovanni Maria (1625–1665), Ferdinando (1657–1743), Giuseppe (1696–1756) and Carlo (1728–1787). They worked in Venice, Berlin, Dresden, Munich, Prague, Vienna, Bayreuth and innumerable other cities. The single

most lasting achievement was Ferdinando's invention of the diagonal axis sytem, first presented in 1703 at the Accademia del Porta in Bologna. This involved shifting the central axis to reveal additional rooms or spaces which were visible to the audience at an angle (*veder la scena per angolo*), so that the technique came to be known as *scena per angolo*. Ferdinando elaborated his theory of this technique in 1711, making it widely available. Yet there was more to this innovation than simply breaking the mould of traditional Baroque stage design.

The very fact that it abandoned the hierarchy of axial systems is not only symptomatic of the very essence of Rococo, but also indicates a change in the interaction between the scene and the spectator. Having exhausted the illusory powers of the visible, the illusory powers of the labyrinthine now came into their own. The strict regulation of ceremony required by the Baroque stage set is not possible in a *scena per angolo*. The decentralization of the stage automatically results in a decentralization of movement on stage, leading to an interesting dissolution and simultaneous emphasis of the contradiction between "artifice" and "nature". If the events presented on such a stage are seen to occur "naturally", this is, of course, the result of artificially created conditions.

The stage designs of the Galli Bibiena herald the dawn of a new era in yet another important way. They are the visual expression of a

1785 — The first edition of "The Times" appears in England. **1786 — Europe's highest peak, Mont Blanc, is climbed for the first time.**
1787 — The first steam engines are employed in textile manufacture.

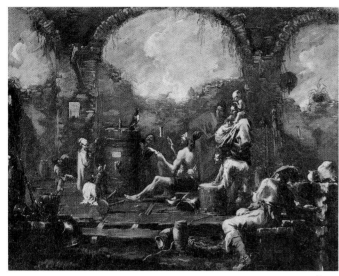

19. ALESSANDRO MAGNASCO

<u>The Wise Raven</u>
c. 1703–1711, Oil on canvas, 47 x 61 cm
Florence, Galleria degli Uffizi

20. FRANCESCO GUARDI

<u>Capriccio</u>
c. 1745, Oil on canvas, 92 x 132 cm
Mailand, Crespi collection

19

new form of rhetoric whose persuasive powers lie in indirect statement rather than in clarity of structure and logic. Slanting walls provide concealment, corners harbour clandestine meetings, angles are sources of surprise. The spectator is entranced by the possibilities of the unexpected and the unforeseen, and illusion is catapulted out of invisibility. It thus becomes possible to transform an entrance into a portentous event – a development soon adopted in an area that seems diametrically opposed: religious art.

Pious imagery of ROCOCO

The extension of real space into ceiling paintings by transposing architectural detail in the manner invented by Pozzo (who was himself a set designer) still owes much to Baroque rhetoric. In the ceiling frescoes created by Cosmas Damian Asam (1686–1739) for the monastic churches of Weingarten (1718/19) and Aldersbach (1720) celestial events unfold in hierarchical ranks. Even in Weltenburg (ill. p. 31) the boundaries between these individual planes of action are blurred. There, too, on another level, the "theatrum sacrum" or sacred theatre is staged. St George appears against a background of light. The stucco figure is freestanding in an illuminated, stage-like setting created specially for it. The *Assumption of the Virgin* in the monastic church of Rohr tells us that the miraculous event is a palpable occurrence close to human experience.

In this regard, it seems only logical that, for example, the ceiling painting in the pilgrimage church of Steinhausen by Johann Baptist Zimmermann (1680–1758) or Schloss Nymphenburg (ill. p. 63), should show a landscape – the earthly zone, as it were – surrounding the celestial centre like a frame. In this way, the artist creates a stage for both sacred and mortal actors. The miracles are comprehensible, present and yet distant, at once tangible and inaccessible, for the human proximity and explanation of the appearance are countered by the hermeticism of the image that now makes no pretence to be anything but an image. This adaptation of theatrical and stage set devices is also evident when the stage remains empty.

In Zimmermann's ceiling fresco for the church of Wies, the heavenly gates remain closed, the celestial throne unoccupied, and the Supreme Judge appears between them in the clouds on a rainbow of conciliation. The tension between the two unoccupied areas, facing each other at east and west like opposite poles, is further heightened in this way, and the focus is on the message announced by Christ in the centre. The spectator experiences the doctrine of salvation indirectly rather than directly, in anticipation of it, rather than in its fulfilment.

1788 — The Constitution of the USA comes into force. 1789 — Start of the French Revolution.
1791 — Washington is founded as capital and seat of government of the USA.

> **"Artists work 'di fantasia o di capriccio' when they create something without a model, from their own imagination and without nature as an example."**
>
> Filippo Baldinucci

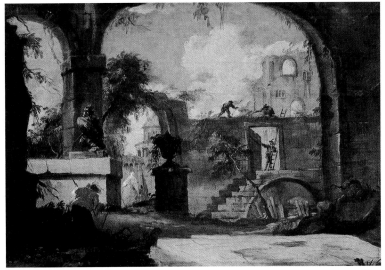

20

When Johann Evangelist Holzer (1709–1740), Franz Anton Maulbertsch (1724–1796), Zimmermann or Matthäus Günther (1705–1788) integrate folkloristic elements into the realms of religious art and when Tiepolo includes objects of everyday Italian life in biblical scenes, they are using a similar formal language. To interpret Rococo as an era of diminished piety is to misconstrue that language. It is a language that makes use of new vocabulary and new rhetorical means in order to convey its message.

The significance of the individual and individuality

The only way to approach the art of the 18th century is by seeking to understand the forms, the techniques, the categories and the values of Baroque without actually accepting them as valid standards. Never before did individuality and subjectivity play such a major role in art. It is a focal theme in portraiture, which explores the unique and the individual, not only in human beings, but also in animals. Even the precision with which an urban landscape is rendered becomes a unique and individual portrait of a city. Moreover, individuality is also a mode of presentation that is included in the picture as an independent value, as in the capriccio. It is only by understanding the dominance of artistic per-

sonality over trends, stylistic characteristics and concepts of collusion in this era that we can understand the greatest artists of the period.

Tiepolo and Goya, Piranesi and Hogarth, William Blake (1757–1827) and Chardin cannot be classified as artists of a single stylistic epoch. Their works may be shaped by the visual experience and *Zeitgeist* of their generation, but they still transcend it and its terminological classifications. Perhaps it is precisely this blurring of boundaries in the Rococo era that made it possible for such unique talents to flourish in the first place.

1792 — Civil marriage is instituted in France in place of church marriage.

1794 — The first technical university is founded, and the first technical museum opened.

тhe strasbourg Belle

Oil on canvas, 138 x 106 cm
Strasbourg, Musée des Beaux Arts

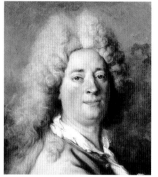

b. 1656 Paris
d. 1746 Paris

Largillière first studied art in Antwerp, qualifying as a master artist in 1672. Two years later he went to London, working with the Flemish-born Peter Lely and also for the court. To avoid persecution as a Catholic he had to return to Paris in 1682. With a portrait of Charles Le Brun (ill. below) he was accepted as a member of the Academy. He was again in London in 1685/86 in order to paint the royal couple at the coronation. Alongside Hyacinthe Rigaud, Largillière was the most sought-after portraitist among royalty, nobility and the middle classes. As a teacher – he became professor at the Academy in 1705 – he upheld the Flemish tradition which had long played an important part in French painting. He was also a master of the group portrait and the still life.

We no longer know the name of this beautiful woman. Yet even though Nicolas de Largillière painted this as a portrait of a specific beauty, who sat as his model, her individuality seems to be secondary to her clothing and her origins. It is her traditional Strasbourg costume that is the real subject matter of the painting, rendered in meticulous detail with all the masterly skills that betray this artist's Flemish training. The lace trims of her shawl and jabot, the magnificent folds of the sleeves, the firmly laced corset with its sumptuous border and, by contrast, the simple skirt and unadorned wide-brimmed hat – these are certainly not just demonstrations of painterly skill. They indicate that this painting was intended to portray a specific costume, rather than a specific person.

The delicate beauty of the woman thus takes on a universal and non-committal quality, in contrast to which her clothing is special and characteristic. At the same time, the elegance of the pose and the fine facial traits suggest that this is not some rural beauty proudly presenting her finest clothes, but a sophisticated woman of the world, her lapdog on her arm, who has chosen this peasant costume as a disguise in order to make the illusion of a naive sense of unbroken tradition the vehicle of a life of leisure.

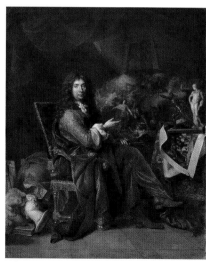

Charles Le Brun, first Painter of the King, undated

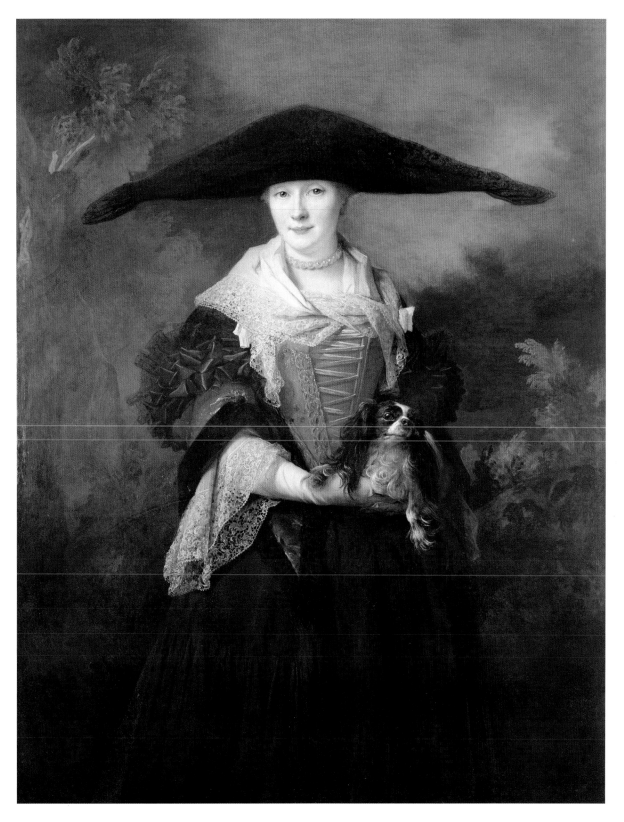

portrait of a young girl

Pastel, 36.3 x 30.3 cm
Paris, Musée National du Louvre

===

b. 1675 Venice
d. 1757 Venice

As a pupil of Giuseppe Diamantini and Antonio Balestra, Rosalba Carriera initially gained her reputation as a painter of miniaturist portraits. Augustus the Strong, King of Poland, was portrayed by her on several occasions. Her brother-in-law Giovanni Antonio Pellegrini seems to have encouraged her to take up pastel painting. By using this technique in portraiture and perfecting its artistic possibilities, which lie between drawing and painting, Carriera was, if not the inventor of pastel painting, at least the creator of a new influential form of portraiture – the face of the age. At the age of thirty she became a member of the Accademia di San Luca in Rome. Her visit to Paris in 1720, where she painted *Louis XV as Dauphin* (Dresden, Gemäldegalerie) and exchanged pictures with Watteau, was of great significance to French pastel painting.

In choosing pastel, Rosalba Carriera opted for a technique that allowed her to flatter her models without pretentiously idealizing them – which may explain the success she enjoyed despite her lack of artistic brilliance. Her best works were created when the gentle appeal and flattering softness of pastel complemented the personality of the sitter.

This is certainly true in this portrait of a young girl. The mother-of-pearl flesh tone has been rendered in classic pastel hues of blue, pink and pale grey, and the lack of depth in colority is perfectly suited to capturing this almost childlike face that has not yet experienced life.

Pastel does not lend itself to the portrayal of shadow and is suited to depicting a life of carefree youth that knows no shadow either.

The softness of this charming face relates perfectly to the technique. Apart from the compatibility of subject matter and medium, Carriera's achievement consist in her ability to subordinate the facial expression to the mood of the picture without losing the individuality of the sitter's appearance. The girl looks at us with a mild and almost lustreless gaze, an almost imperceptible smile on her lips. All excitement, abruptness or suddenness that would contradict the pastel, is avoided. The quality of the painting lies in its delicate uniformity.

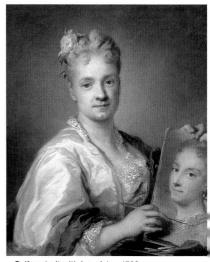

Self-portrait with her sister, 1709

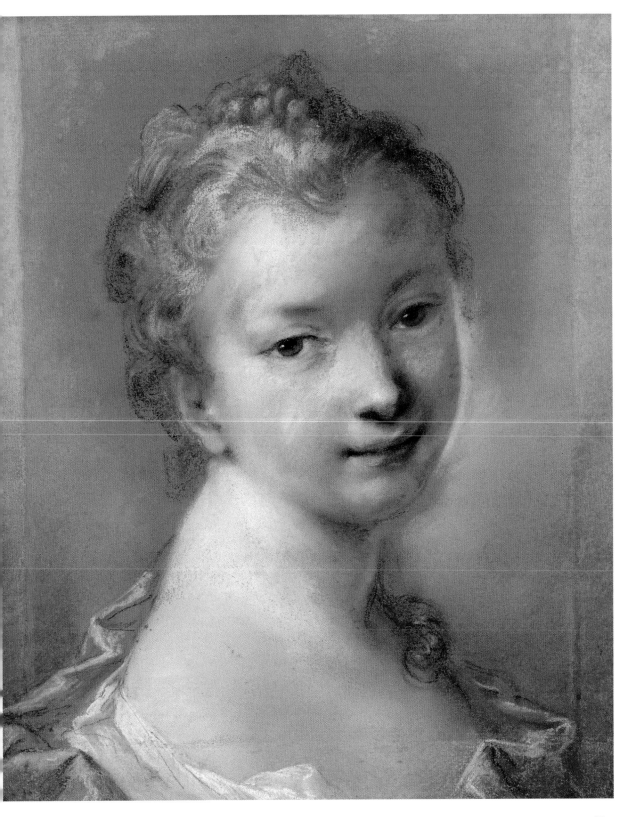

Fêtes vénitiennes

Oil on canvas, 55,9 x 45,7 cm
Edinburgh, National Gallery of Scotland, Bequest of Lady Murray of Henderland 1861

b. 1684 Valenciennes
d. 1721 Nogent-sur-Marne

As the son of a craftsman Jean-Antoine Watteau was apprenticed to a decorative painter at the age of eleven. About five years later he left for Paris and joined the Flemish artists' colony in St Germain-des-Prés. His master Claude Gilot introduced him to the world of the theatre and elegant society. After a dispute with Gilot he painted for the art dealer Sirois scenes from military life in 1709/10. In 1712 he was accepted by the Academy, and five years later he became a member with his *Pilgrimage to Cythera* (ill. below). As this picture did not fit into any of the currently existing categories, a new one was created, and Watteau became a "peintre des fêtes galantes". In this way Watteau's own creation, the elegant party group, achieved respectability in academic circles.

From then on, Watteau's work became dominated by the poetical representation of love. The theatre, music, the conversation piece and mythical scenes, all enter the realm of love. His extremely fine palette reveals Flemish influences, particularly that of Rubens, and his draughtsmanship was superb. His patron Crozat's collection of graphic works by Renaissance masters gave him ample scope for study in this field. Apart from elegant party scenes, Watteau excelled in the portrayal of scenes from Italian comedy. In the last two years of his life he suffered from tuberculosis. He went to London for treatment and on his return retired to Nogent-sur-Marne, where he died, not yet aged forty.

In this "fête galante" nothing and no one seems to be the centre of attention. The couple dancing a minuet seem completely absorbed, the bagpipe player gazes dreamily into space, a cavalier is busy in his conquest of a beautiful woman, a couple is strolling in front of the fountain, two women and an actor are engaged in deep conversation. All in all, the materials have a certain similarity, and all add to the sense of celebration.

Watteau included himself as the seated musician playing a musette. The central dancer may be the leading actress Charlotte Desmares, who was mistress of the Duc d'Orleans. Her male dancing partner is Nicolas Vleughels, a Flemish painter, who was Watteau's friend and landlord. The painting may contain a private meaning enjoyed by the two artists. The other figures are based on drawings Watteau made from his direct observations of contemporary society.

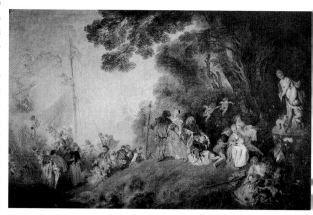

Pilgrimage to Cythera, c. 1718/19

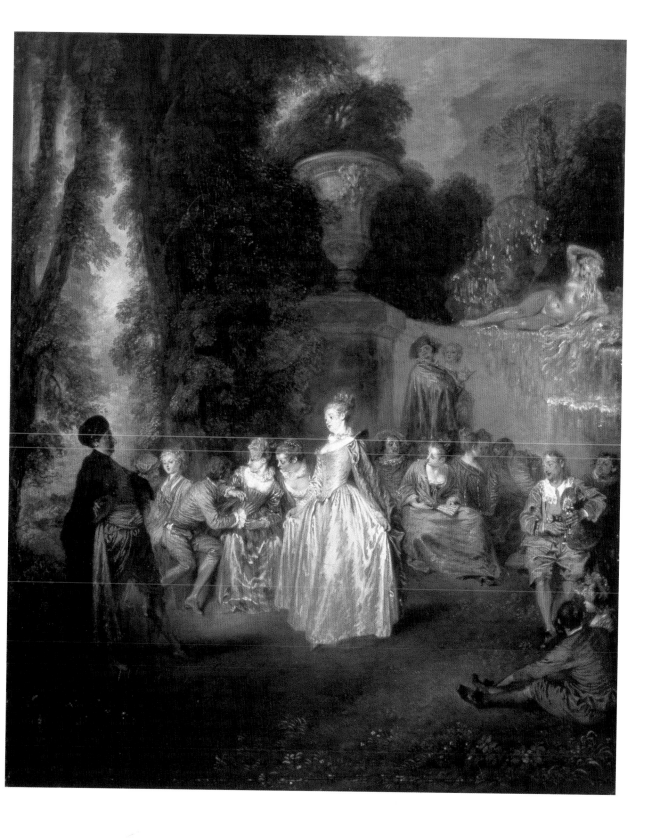

st George worshipping christ and the virgin

Ceiling fresco

Weltenburg, Monastery Church of St George and St Martin

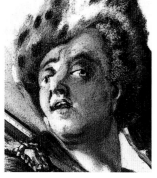

**b. 1686 Benediktbeuren
d. 1739 Munich**

Cosmas Damian, together with his brother Egid Quirin, with whom he worked later, was trained by his father Hans Georg Asam, who is considered to be the founder of Baroque ceiling painting in Bavaria. In the years 1712 to 1714 the brothers travelled to Rome, where Cosmas Damian took up his studies under Pierleone Ghezzi and won an academy prize. He concentrated mainly on wall and ceiling painting of the High Baroque, in particular in the style of Cortona and Pozzo, who in 1702 had published a book of rules on quadratura, a form of ceiling decoration with architectural elements, which give the illusion of perspective and imaginary space.

The work which he carried out on his return in south Germany, Bohemia, Silesia and the Tyrol betrays his Roman schooling. However, he gradually abandoned the Italian quadratura technique in which the illusionism is solely directed at the viewer (Weingarten, Aldersbach). Finally, as in the principal fresco at Osterhofen, each side commands its own viewpoint. His work, both sacred and secular, such as at Weltenburg on the Danube 1716–1721, in which his brother was also engaged as sculptor and ornamental plasterer, contains examples of late Baroque art which was to become important for the Rococo in southern Germany.

Above the oval main room of the monastery church, a broad concave moulding marks the transition to a domed ceiling. The vaulting opens up into a diadem borne by angels, reiterating the oval groundplan. Illuminated by invisible windows, we see the saints of the Benedictine order in all the glory of the heavens.

It is quite impossible for the spectator to see that this domed setting is actually flat, and that the whole work is not, as is so often claimed, a domed ceiling fresco. By creating a transition from oval to circle, Asam is able to interweave the clouds amongst the pillars so that they help to conceal the base of the (painted) round temple on the oval ceiling aperture. A more intense metaphor for the heavens as a domed and pillared temple borne on clouds can hardly be imagined.

On the main side of the fresco we see St George with his eyes raised towards Mary as she is carried upwards to Christ and God, who is holding a crown above the starry nimbus around her head. It is the triumph of the church that is displayed here against the golden background bathed in light, and its effect is all the more overwhelming because Asam has made the architecture his accomplice in illusion.

Madonna of the Rosary, 1738

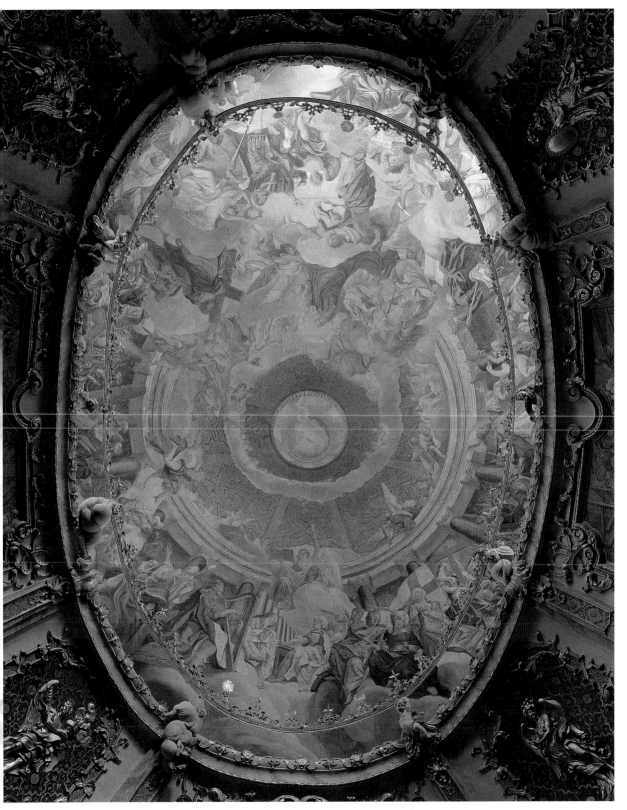

Beggar Boy

Oil on canvas, 66.7 x 54.7 cm

Chicago (IL), The Art Institute of Chicago, Charles H. and Mary F.S. Worcester Collection, 1730. 747

b. 1683 Venice
d. 1754 Venice

Piazzetta received early instruction from Antonio Molinari, but Giuseppe Maria Crespi in Bologna became his real teacher. To him he owed his loose manner of painting; an earthy, warm palette competing with whites, and a chiaroscuro used to create an atmosphere rather than the pathos which had been produced until recently by Johann Liss and Johann Carl Loth. When he left Crespi and returned to Venice in 1711, his art presented a complete contrast to the prevailing Venetian style as represented by Ricci, Pellegrini and Amigoni. It was not until the 1720s that Piazzetta used lighter tones. His scenes from the Old and New Testaments were painted in the genre style, and have an almost tactile closeness. Piazzetta is regarded one of the most important representatives of 18th century Venetian painting.

The creation of an independent pictorial language capable of capturing the wealth and poverty, comedy and tragedy, serenity and gloom of Italian life is the achievement of such artists as Longhi, Magnasco and Piazzetta, who created a distinct counterpoint to the artificiality of French genre painting.

The young beggar boy here with his chubby cheeks, his strong neck and his child-like stature is not a pathos-laden appeal to the spectator, nor one that calls for sympathy. There is nothing servile in his bearing or his direct gaze and the rosary in his grubby hand is not a sign of hypocritical piety, but an object of his daily life.

Piazzetta allows the pictorial means to become bearers of expression in themselves. The background of the painting and the coat are brown as the naked earth: poverty is clearly something elementary, and not just picturesque decay. The red of the waistcoat is vigorous and strong. A vibrant southern light is reflected in the white of the sleeve, freshness and sunshine in the boy's brown complexion. There is no sentimentality in the harmony of technique and subject matter, but a certain candour that touches the spectator.

The Sacrifice of Isaac, c. 1715

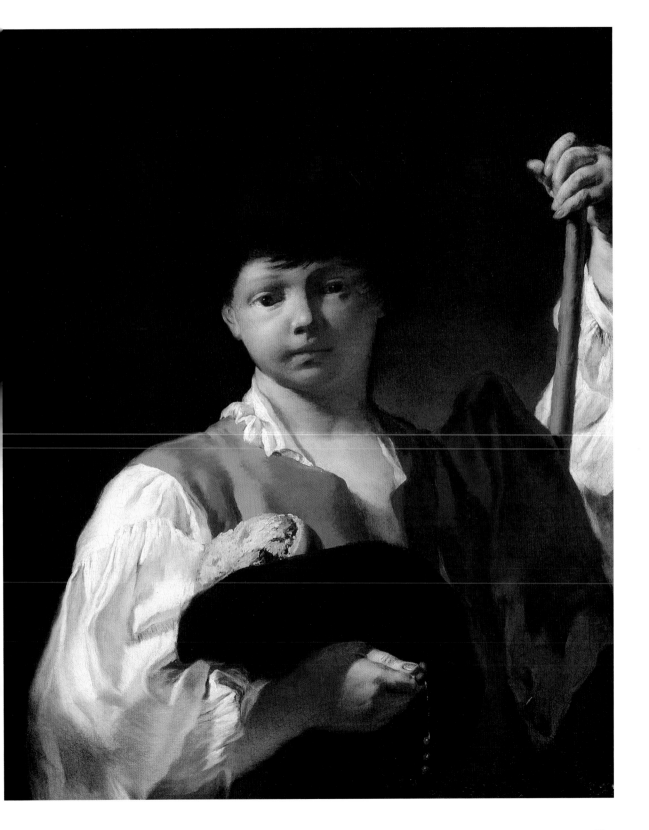

Hagar and Ismael in the wilderness

Oil on canvas, 140 x 120 cm
Venice, Scuola di San Rocco

b. 1696 Venice
d. 1770 Madrid

Tiepolo was the son of a ship-broker. His teachers were Lazzarini and the old masters, amongst whom he studied Titian and Tintoretto and in particular Veronese, to whose style he owed much. In 1719 he married a sister of the painter Guardi. His eldest son was Giovanni Domenico, who later became his assistant and successor. Tiepolo's early work still showed the influence of Piazzetta, Bencovich and Ricci. A high point in his early career were the frescos in the archbishop's palace in Udine, which anticipated his mature style. The sombre 17th century tonality was giving way to a light, transparent palette. This new lightness also determined the coloration of his many panel paintings. In the 1740s his son became his most faithful assistant in dealing with the large number of often extensive commissions flowing in from Venice, Milan, Bergamo and Vicenza. His finest achievement and largest of undertakings abroad was the commission by the Prince-Bishop of Würzburg to decorate the ceiling of the Kaisersaal and the huge staircase of his nearly completed residence at Würzburg with historical and allegorical scenes glorifying the bishopric and the noble family to which the Prince-Bishop belonged. A further period of eight years filled with a wealth of commissions in and around Venice went by before a second call from abroad arrived.

In 1762 Tiepolo and his son travelled to Spain, partly on a diplomatic mission, but mainly to follow an invitation by Charles III to decorate the royal palace in Madrid. Tiepolo never returned to Italy but died in Madrid, where his art was to be replaced by Neo-Classicism as expounded by Winckelmann who had an influential follower in Mengs.

Tiepolo's son Giovanni Domenico (1727–1804), besides acting as assistant to his father on large commissions, was an original painter of religious and secular works in his own right. He brought his father's enigmatic imagination into the bizarre world of the *commedia dell'arte* the fun-fair and carnival genre, in which his cool tonality became increasingly rationalised. Like his father he was also a master of drawing and of the graphic arts.

Hagar, Isaac's maid, bore him a son, Ismael. When Isaac's wife Sarah drove Hagar and Ismael into the wilderness, an angel saved the child from thirst by showing Hagar the way to a well. Unlike Claude Lorrain, Tiepolo does not situate this Old Testament episode in an empty, sweeping landscape, but presses it into a dense composition. In the foreground lies the pale, exhausted and thirsting child, behind it the beautiful figure of Hagar, pleading with the angel and indicating Ismael's plight.

The angel, a strong and very real figure, passing so close that he brushes against her shoulder, looks down with sympathy upon the suffering child and points the way to the well. The helplessness and urgency of the mother are not presented here by showing her as a forlorn figure in some vast expanse of space, but by portraying her in a gesture of mourning reminiscent of a pietà. The urgency with which Hagar pleads for help for her son is heightened by the density of this crowded composition.

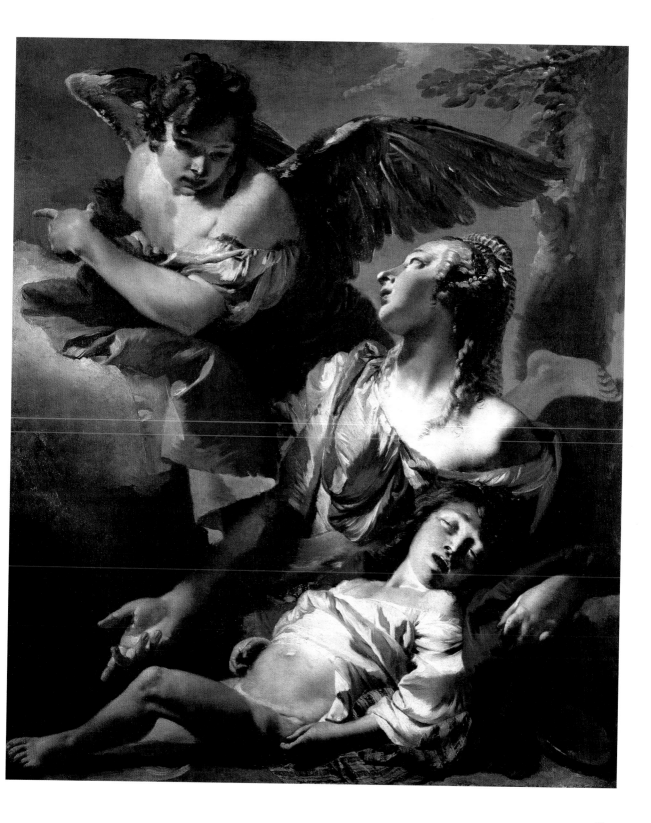

The swing

Oil on canvas, 70 x 89 cm
London, Victoria and Albert Museum

b. 1690 Paris
d. 1743 Paris

Lancret received early instruction in engraving and drawing, then at the age of 17 became the assistant of the history painter Pierre Dulin in Paris. He was not very successful in this field and the hoped for Rome prize of the Academy was not forthcoming, so on entering the studio of Gillot, who had also been the master of Watteau, Lancret gave up history painting. Two landscapes secured him membership of the Academy in 1718. His pictures show from the very beginning the influence of Watteau, with whom he soon quarrelled. A renewed attempt at history painting failed in 1723/24. He now devoted himself to the pastoral idyll and "fêtes galantes". Pictures such as *The Swing* made him something of a mediator between Watteau and Fragonard, although he never achieved their subtle poetic qualities. On Pater's death, Lancret completed the series of illustrations for La Fontaine's fables. With the exception of the *Tiger Hunt* (Amiens, Musée de Picardie) and his portraits, Lancret remained faithful to his so-called "Watteau genre".

Lancret is regarded alongside Jean-Baptiste Pater as the most important representative of the many artists influenced by Watteau, most of whom chose individual motifs or groups from his "fête galante" and made them independent themes. This process alone is indicative of a specific tendency in Rococo: the tendency towards small scale, intimate scenes. In Lancret's painting *The Swing* we find a highly popular motif of the time, treated not only by Fragonard, Boucher and Pater, but also by lesser painters of the era. Just what made the swing such a popular theme becomes clear here.

It is not only the erotic aura, whose "moment of happiness" is to be found in a glimpse under the petticoats, but also the fact that the swing is a metaphor of an interim realm belonging neither to the earth nor to the air. It remains intangible, allocated neither to an element nor to a physical place. Non-committal coquettishness, the freedom of intimacy, the bonds that do not tie: all these are evoked by the rope with which the desiring cavalier is moving the swing, not as a symbol, but certainly as an obvious suggestion.

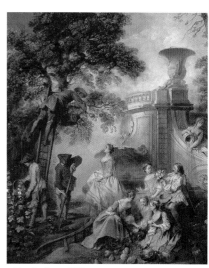

The Earth, c. 1730

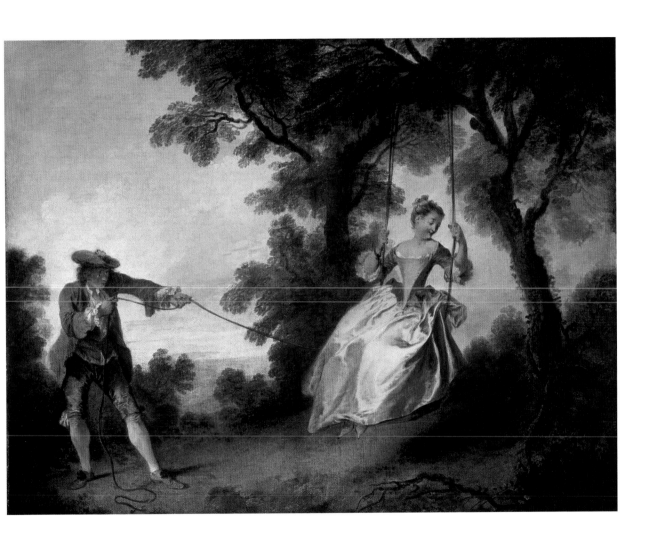

regatta on the canale grande

Oil on canvas, 117.2 x 186.7 cm
London, The National Gallery

b. 1697 Venice
d. 1768 Venice

As the son of a painter of stage sets, Canaletto (Giovanni Antonio Canal) was trained in the craft of perspective painting for the theatre, and this was to be a decisive influence on his later work. When in Rome in 1719 he became acquainted with veduta painters. His friendship with Giovanni Paolo Pannini, Vanvitelli and Carlevari resulted in his emphasis on chiaroscuro in his early work. Besides topographical views, his early work also included architectural fantasies and ruin capricci. His pictures were particularly sought after by English collectors, and Canaletto used agents who sold his pictures.

The demand was so great that he went to England to paint views of London and of country houses. These pictures are already in the lighter, clearer coloration which he had adopted in the 1730s – a quality he transferred to a certain degree to his graphic work. His avoidance of strong chiaroscuro contrasts in his middle and late work led to the erroneous assumption that Canaletto had abandoned the Baroque. His treatment of light does, indeed, belong to the Baroque, while his discoveries in the coloured rendition of views were to prepare the way to the open-air painting of the 19th century.

The fact that, even in his own lifetime, Canaletto was not only imitated by such artists as Michele Marieschi, but was forged on a considerable scale, is proof indeed of the popularity of his paintings. His first buyers were predominantly English, commercial representatives, diplomats and travellers on the obligatory "grand tour". The Duke of Bedford commissioned a series of 24 vedute and John Smith, the British Consul in Venice, ordered 36.

Processions and festivals, ceremonies and regattas – even Gentile Bellini's 15th century paintings bear witness to the brilliant pageantry of La Serenissima. Canaletto not only continues in this tradition, but actually revives it, adding to it his own views and temperament and clothing it in the garb of his own era. Whether he portrays the city's Ascension Day celebrations, the symbolic marriage of Venice with the sea, or the arrival of the Doge: it is no longer with the grand choreography and dignified regularity that dominates Bellini's paintings.

In this painting, Canaletto shows the Canale Grande teeming with boats, the gondolieri in their traditional costumes, the colourful decorations, the crowds lining the banks of the canal, the flags and pelmets on the windows and balconies. What is more, he conscientiously renders a specific location in Venice, seen from the Ca' Foscari, with its palatial facades, its simple houses, its stairways, rooftops, chimneys and terraces and between them all, the wide, azure expanse of the canal. He is fascinated by the contrast between the momentary pageantry with all its light and colour, its exhilarating presence, and the city itself, steeped in tradition, in which celebration after celebration passes through its ancient walls down the centuries.

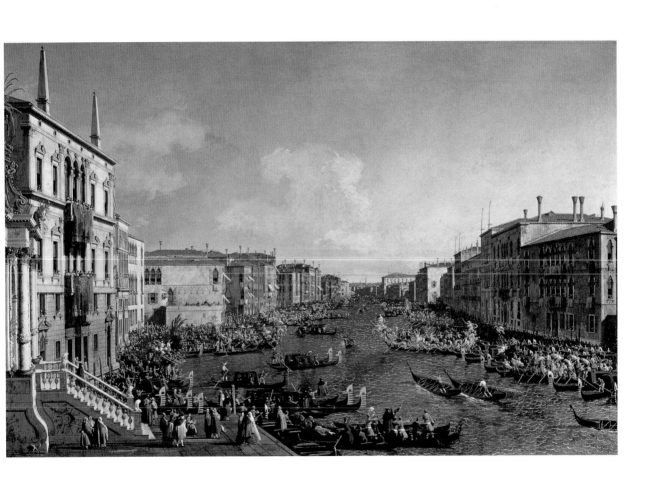

тhe kitchen maid

Oil on canvas, 46.2 x 37.5 cm
Washington (DC), National Gallery of Art, Samuel H. Kress Collection

b. 1699 Paris
d. 1779 Paris

Chardin's father, a decorative cabinet-maker and legal adviser to his guild, first sent his son to an insignificant teacher, then in 1720 to Nicolas Coypel, who trained him as a painter until 1728. Since 1724 he had also been enrolled at the Academy of St Luc. He gained further experience by restoring the frescos of Rosso and Primaticcio at Fontainebleau under van Loo. He first came to public notice in 1728 when he exhibited some works at the *Exposition de la Jeunesse*, including the famous still life *The Ray* (1728; Paris, Louvre), and at the recommendation of Largillière, became a member of the Academy as an "animal and fruit painter". Chardin, who had exhibited his work at the Salon since 1737, now also painted genre pictures as well as still lifes, but the academic hierarchy considered neither of these categories worthy of much attention. In 1740 he showed the King his pictures *The Diligent Mother* and *Saying Grace* (both 1740; Paris, Musée du Louvre), and under royal patronage was appointed adviser to the Academy in 1743. Public recognition of his still lifes came in the 1750s and 1760s. By now he was also trying his hand at portraiture, though with little success.

Chardin had to resign his various Academy posts in 1774 because of an eye disease. Soon afterwards his friend, the influential engraver Cochin, who had secured many commissions for him, fell out of favour. As for Chardin, his period had come to an end. The new classicism left no room for his style and choice of subjects, but he was rediscovered in the 19th century by the brothers Jules and Edmond Goncourt and especially the Impressionist painters with their new treatment of light, who saw Chardin as the last outstanding master of the *ancien régime*.

A contemporary art connoisseur described Chardin as "the French Teniers". Certainly, this interior is reminiscent of the interiors of Teniers' era. Light and colour are subdued, nothing is sudden or jarring. When we think of such painters as Fragonard or Boucher, this painting hardly seems to fit our concept of Rococo art. However, if we bear in mind that conscious repression and compensation of apocalyptic fears were fundamental characteristics of the Rococo age, then *The Kitchen Maid* is indeed a Rococo painting.

The reference to Netherlandish kitchen scenes is soon found to be merely superficial, for the similarity is restricted only to the choice of props and the predominantly brown colouring. It would also be wrong to see any allegorical statement in this scene. It simply shows a kitchen maid in an indeterminate room, pausing for a moment in her work. Her expression is one of neither sadness nor joy, her gaze is aimless but not forlorn. The pictorial space, which initially appears to be firmly bounded, turns out to be a kind of nowhere, whose shelter is created entirely by an inner integrity. The moment of contentment and repose freezes into timelessness, into an eternity that harbours a refuge from fear and transience.

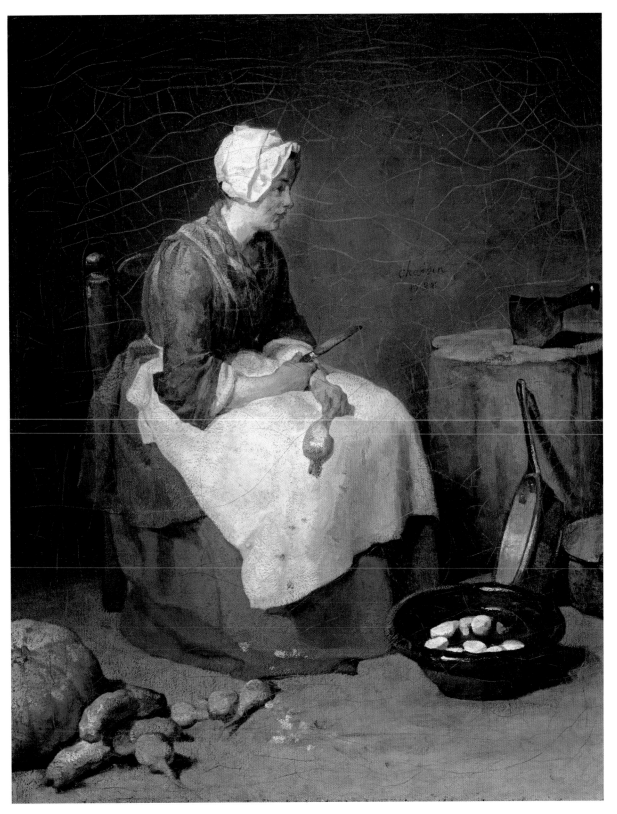

Turkish woman with a Tambourine

Oil on canvas, 63.5 x 48.5 cm
Geneva, Musée d'Art et d'Histoire

b. 1702 Geneva
d. 1789 Geneva

Liotard, whose family was French, was trained as a miniature-painter and engraver in Geneva. In 1723 Jean-Baptiste Masse became his teacher in Paris. His friendship with Lemoine inspired him to take up pastel and portrait painting. A visit to Rome, where he copied old masters, in particular Correggio, was followed by eastern travels in 1738, accompanied by Sir William Ponsby. During his five-year stay in Constantinople he adopted Turkish customs and traditions. In Vienna he painted the Empress Maria Theresia's family and the famous *Chocolate Girl* (Dresden, Gemäldegalerie). As portrait painter he worked in Venice, Lyon, Paris and London before settling finally in his home town in 1757. His work is characterised by light coloration and detailed rendering of a world almost without shadows. Liotard's perfectly even surfaces give away the fact that he had trained as an enamel painter.

From 1738 to 1743, Liotard lived in Constantinople, where he learned the Turkish language and adopted the local clothing and lifestyle. The attention to detail in this painting indicates his astute powers of observation as well as his technical brilliance. Liotard's fame is founded primarily on his qualities as a pastellist and this painting is an oil replica of a smaller pastel (Zurich, private collection). This allowed him to explore other aspects of the subject matter and set other accents.

Whereas the powdery, velvety surface of the pastel and its predominantly whitish tones may be appropriate as a flattering medium for the portrait of an elegant woman of Parisian society, the strongly coloured charms of the Turkish costume can be rendered with considerably greater intensity in oil. The vibrant colours, the brilliance of the gold brocade, the silken sheen of the baggy trousers – everything in the picture is saturated with colour and light. Only the flesh tones are reminiscent of pastel techniques.

The woman in this painting has the perfectly groomed face and pale complexion of a Frenchwoman whose picturesque pose seems to clash with the sumptuous richness of the costume and the setting. "Turquerie" was a popular exotic fashion imported during the Rococo period and this is not only the subject matter of the painting, but is also evident in the painterly techniques. The contrast between the "pastel style" and the "oil painting" indicates that this is a precious model in disguise who wishes to be recognized as such.

He had visited all the great cities of Europe, and had painted portraits of Pope Clemens XIII and Empress Maria Theresia by the time he returned to his home town of Geneva as portraitist to high society. There is no shortage of self-assurance in the way the artist writes of his talents, pointing out in particular his portraits of François Tronchin, scion of one of the oldest and wealthiest families of the city, and his wife (ill. p. 20).

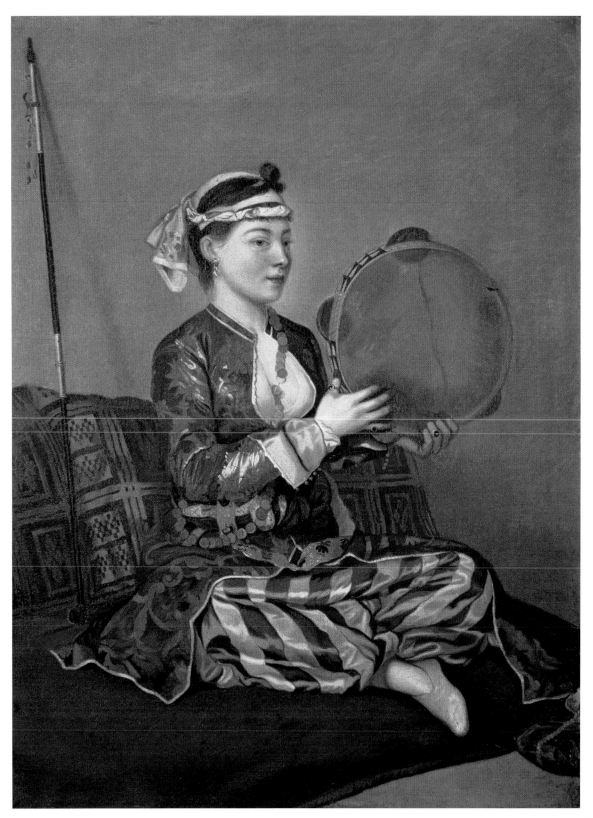

тhe вreakfast

Oil on canvas, 81.5 x 65.5 cm
Paris, Musée National du Louvre

b. 1703 Paris
d. 1770 Paris

His father, a designer of embroidery patterns and ornaments, apprenticed the 17-year-old to François Lemoine. Apparently he stayed there for only three months, and then went to work under the engraver Jean François Cars. Already in 1723 he won the "Grand Prix de Rome", but did not visit Italy until four years later. On his return in 1731 he was admitted to the Academy as historical painter and in 1734 became a member. Rising from professor to rector and director of the Academy, his brilliant career culminated in his appointment as head of the Royal Gobelin factory (1755) and finally as "Premier Peintre du Roi" (1765).

The young Boucher developed his style by drawing primarily on Adriaeb Bloemaert, Peter Paul Rubens and Jean-Antoine Watteau. His early work celebrates the pastoral and idyllic, sometimes in childlike diminutive. He depicts nature with ingenious artifice, also creating pure landscape.

The eroticism of his shepherds and shepherdesses is given a very thin veneer of innocence. Mythological scenes with Venus as the focal point are treated on the level of mere amorousness and sensuality; there is no heroism: Mount Olympus has been replaced by the boudoir seen from the perspective of the keyhole. In his portraits, too, Boucher's work realises the Rococo in its purest form. In his final creative years he became the butt of the critics of the new morality and pathos as advocated by Denis Diderot.

This scene of a family breakfast does not radiate any sense of warmth, maternal happiness or security. The elegant young mother merely turns as though by chance towards the child who is busy with its toys. A nursemaid has a little girl on her lap, stiff as a china doll. Even the servant holding the jug seems uninvolved. The atmosphere in this painting is one of unqualified serenity and levity.

The children are symbols of freedom from care, the women and the servant embody youth and beauty, the morning hour is free of shadow. The mirror, the gilding, the golden-yellow drapes, the pale porcelain and the high window are all bearers of lightness and brightness, with neither shadow, age nor poverty. Behind it all, the fears of transience are merely hinted at.

> **"тhose colours which seem most appropriated to beauty, are the milder of every sort; light greens; soft blues; weak whites; pink reds; and violets."**
>
> **Edmund Burke**

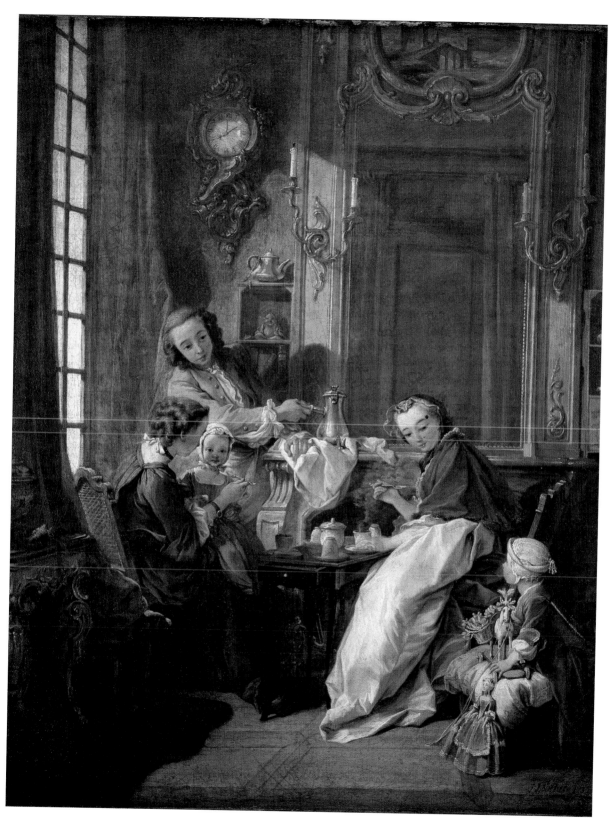

тhe shrimp girl

Oil on canvas, 63.5 x 52.5 cm
London, The National Gallery

b. 1697 London
d. 1764 London

Hogarth, the son of a schoolmaster, was apprenticed to a silversmith and engraver in 1712, where his interest in copperplate engraving was aroused. He studied at Vanderbank's Academy in St Martin's Lane and at the art school of the court painter Thornhill, whose daughter he married in 1729, and whose work left him with a life-long ambition to become an historical painter. While he was never to be successful in this field (*Sigismunda*, London, Tate Gallery, 1759), he soon became well-known as an engraver and painter of pictures, such as the series *A Harlot's Progress* (1732), *A Rake's Progress* (1735) and *Mariage à la Mode* (1742–1744). These became so popular that he had to to take precautions against plagiarism.

Hogarth was unfairly accused of uncouth dilettantism in his religious work (*Ascension triptych*, St Mary Redcliffe, Bristol, 1756). His versatility also extended to art theory, such as his treatise directed against academic rigidity, *The Analysis of Beauty*, published in 1753. In portraiture, one of his best works was *Captain Thomas Coram* (London, Foundling Hospital, 1740). Although Hogarth, who on Sir James Thornhill's death became the principal of his art school, had no direct followers, he is regarded as the founder of the English school of painting, and especially of portraiture.

Hogarth originally wanted to become a history painter, but this ambition seems to have been thwarted by a singular lack of interest on the part of his contemporaries. Posterity, too, has chosen to remember a very different Hogarth. He characterized the individual personalities of his sitters, revealed the unique within the typical, and in his tongue-in-cheek portrayals of human nature he documented the social mores of the age in areas beyond the sphere of the "historic" event. Then, as now, he was regarded as the painter of the private, the forgotten and the overlooked.

In the improvised composition of this oil sketch of *The Shrimp Girl*, we see Hogarth's painterly talent at its very finest. Here, he succeeds in creating a spontaneous reiteration of his observations with all the impact of a first impression. The freshness of the moment is not transposed here into a smooth painterly technique, but is echoed in the vigorous and fleeting brushwork.

The Graham Children, 1742

Piazza della signoria in Florence

Oil on canvas, 61 x 90 cm
Budapest, Magyar Szépmüvészeti Múzeum

b. 1721 Venice
d. 1780 Warsaw

Bellotto began his artistic career at the age of fifteen in the workshop of his uncle Antonio Canal and took over not only his speciality of veduta painting, but also largely his style and finally even his name Canaletto. Like his uncle, he also visited Rome and probably Tuscany. He worked in several regions of Italy, including Lombardy and Turin, before travelling to England in 1746. A year later he was welcomed in Dresden by Augustus the Strong. He carried out work for Maria Theresa and the Austrian nobility in Vienna, returning 1762 via Munich to Dresden where, after losing his position as court painter, he took a post as teacher of perspective painting at the Academy founded in 1764. Bellotto finally settled in Warsaw where he became court painter to Stanislas II.

The close connection between uncle and nephew makes it difficult to draw a clear line between Bellotto's early work and the late work of his teacher. A cooler palette and the even greater precision of his topographical views distinguish his independent work from that of Canal. His principal works, such as the 14 Dresden vedutas, or the view of Warsaw, make him the equal of his uncle. His topographical representations of the European royal capitals are also an important historical record on account of their exactitude and faithfulness.

Bellotto, like his uncle, was also known by the name of Canaletto. Bellotto had studied under his uncle, Canaletto, and throughout his life he worked in the same field. Nevertheless, he quickly developed his own artistic profile and his works are easily distinguished from those of his uncle. In his younger years, Bellotto's distinctive style lay primarily in the way he enriched his vedutas with an intensity of atmosphere, either in the quiet melancholy of a cloudy sky, the magical illumination of a setting sun or the calm before an impending storm. Later, having worked in Vienna, Munich and Dresden, finally settling in Warsaw, his style began to lose its picturesque fluidity, gaining in clarity, becoming more sharply contoured, and tending increasingly towards draughtsmanship and line, whereby the emphasis on colour was reduced. In his painting of the *Piazza della Signoria in Florence* he portrays the Palazzo della Signoria, the Loggia dei Lanzi, the façades of churches and houses, rooftops and towers, with painstaking attention to detail. Yet he adds to these detailed documentations his observations of everyday life. The purely documentary is enlivened by the banal, the permanent by the transient. The piazza is bathed in afternoon light, making it unique in a double sense: as an urban architectural complex and as a contemporary urban scene personally experienced.

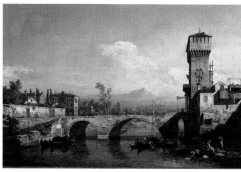

Capriccio Padovano, c. 1740–1742

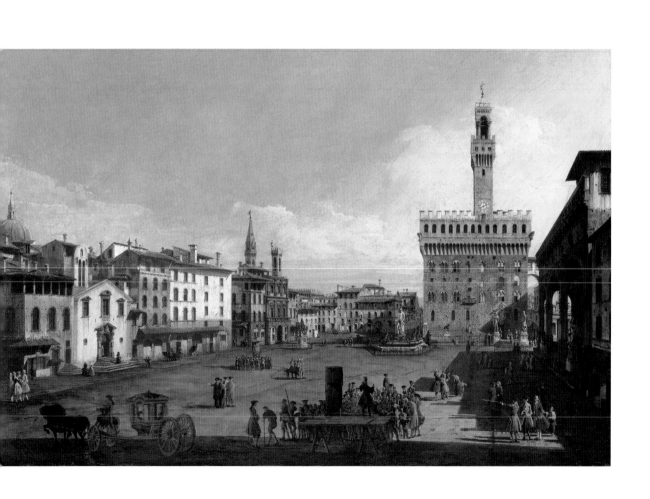

Madame Henriette as Flora

Oil on canvas, 94.5 x 128.5 cm
Florence, Galleria degli Uffizi

b. 1685 Paris
d. 1766 Paris

Nattier received early training from his father Jean-Marc the Elder and then probably was the pupil of Jouvenet. He studied the older masters in the Galerie du Luxembourg, particularly Rubens. At the early age of fifteen he received an Academy prize for a drawing after Rubens, which pleased Louis XIV so much that he had an engraving made of it. The Russian ambassador sent the young Nattier to Amsterdam to paint members of the Tsar's family who were staying there. Nattier's achievement was to translate the traditional type of mythological portraiture into the language of the Rococo (e.g. *Mademoiselle de Lambesc as Minerva*, Paris, Louvre, 1737; *Madame Bouret as Diana*, 1745, ill. below). These paintings, which were not meant to turn the sitters into mythological figures but merely give them their attributes, created a vogue amongst the court ladies and favourites of Louis XV. As such, they form a significant aspect of Louis Quinze painting. Nattier's works are noted for their mother-of-pearl-like lustre, in contrast to High Baroque coloration.

Towards the mid-18th century, the proportion of portraits shown at official art exhibitions increased considerably, prompting critics to demand that in future, only portraits presenting a specifically prescribed theme would be accepted. At the same time, this particular generation of artists produced a great many highly talented portraitists, including Roslin, La Tour and Nattier.

Nattier, more than any other artist, seized the opportunities offered by the Baroque form of *portrait historié*, which presented contemporary persons as historical or mythological figures. He succeeded in linking thematic significance and universality with courtly elegance and decorative pose. When he was finally appointed *peintre du roi*, most of his models were ladies of high society. Even the portraits the king commissioned for his bedroom in Choisy feature two of his daughters – *Madame Adelaïde as Diana, Madame Henriette as Flora* – with the costumes, according to contemporary documents, reflecting their different temperaments.

Nattier reports in his memoirs that, in accordance with the instructions of the queen, he painted the head first. Physiognomic similarity and mythological role, stylistic freedom and the instructions of the client had to be united in an elegant setting.

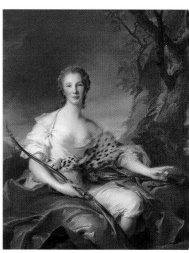

Madame Bouret as Diana, 1745

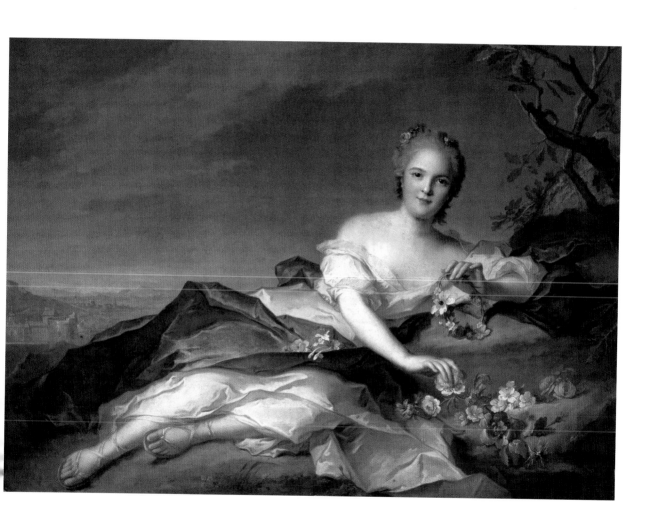

st sebastian and the women

Oil on canvas, 60 x 37 cm
Vienna, Österreichische Galerie, Belvedere

b. 1698 Welsberg near Zell (Tyrol)
d. 1762 Vienna

Little is known about Troger's beginnings. He went to Italy, visiting Venice, Rome and Naples. There he became influenced by the works of Pittoni and Solimena. His first great work was the cupola fresco in the Kajetanerkirche in Salzburg, 1727. In his development as a fresco painter he soon abandoned the sombre, dark tonality of his early work in favour of a more colourful palette which, inspired by Rottmayr, achieved an increasing lightness in his late work (Maria Dreieichen, 1752). In his panel paintings he never achieved this but continued to present his religious scenes in dark contrasts of light and shade. In his frescos he skilfully adapted his handling of colour and his composition to the architecture and the spatial conditions. His spontaneous, often even sketchy approach became a source of inspiration to many significant fresco painters, including Bergl and Maulbertsch, Knoller and Zeiller.

The cult of St Sebastian, who was probably a victim of Diocletian's persecution of the Christians, is documented in early Christian writings and has an unbroken tradition through to the 20th century. The scene Troger has chosen for his altarpiece refers to the legend that tells how Sebastian, Commander of the Praetorian Guard, was shot by archers on the orders of the emperor and later nursed back to health by the Christian Irene, widow of St Castulus the martyr. When he later continued to express his Christian faith, he was beaten to death.

Troger's Sebastian is not the youthful hero of Baroque paintings. There is no radiant certainty of salvation here. Instead, we see a wretched scene of suffering that does not even have the historic pathos of a key event. What is happening here is shown in a shabby secluded setting, far from the public eye. With pragmatic energy, a young woman is untying him, while Irene gently draws an arrow from his body. The suffering of his martyrdom is as tangible as the suffering of any sick neighbour. The assistance is so pragmatic and utterly unheroic that the spectator perceives it as a natural action. In this way Christianity is shown as a faith that can be applied to daily life.

Baptism of Christ, undated

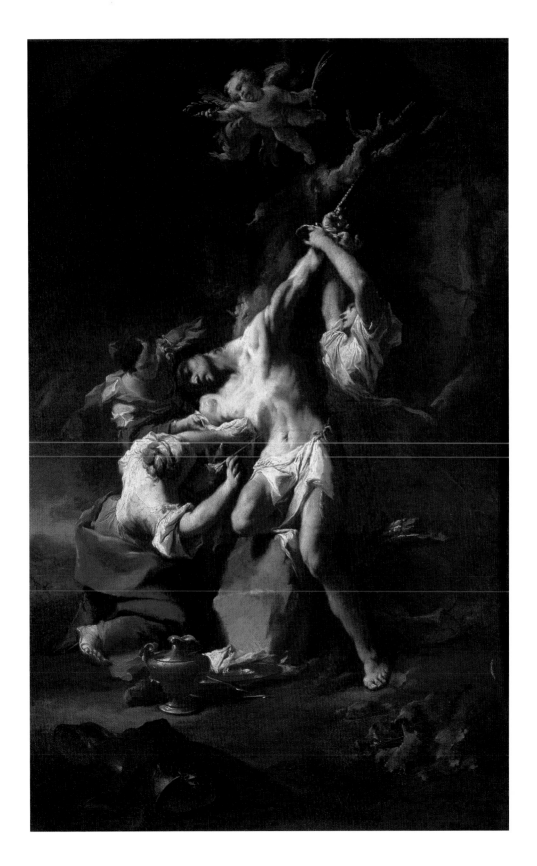

self-portrait

Pastel, 64.5 x 53 cm
Amiens, Musée de Picardie

b. 1704 St.-Quentin (Aisne)
d. 1788 St.-Quentin

Leaving his poverty-stricken home at the age of 15, La Tour first entered the workshop of an etcher in Paris, then worked in the studio of the painter Jacques-Jean Spoëde. With a letter of recommendation from an English ambassador he went to England where he was much impressed by van Dyck's art of portrayal. On his return to Paris he took up pastel painting, possibly inspired by Rosalba Carriera's success in Paris in 1720/21. After some experiments he soon came to excel at pastel portraits, surpassing all his rivals, even Peronneau, and gaining great favour at court. La Tour was most demanding in his art so that the execution of a work was often slow, and it was nine years before he produced a work which would admit him to the Academy. His *Portrait of Mme de Pompadour* of 1755 (Paris, Louvre) and of the *President de Rieux in his Study* (Paris, Louvre) represent two of the few full-length pastel portraits in existence. His portraits show a vigorous handling and a perceptive grasp of character.

When La Tour drew this self-portait (pastel, being made of chalk, is not, strictly speaking, a technique of painting) he was already one of the most sought-after portraitists of his day. Nevertheless, he foregoes all the trappings of ostentation, dignity and solemnity. The intimacy of the pastel, hardly suited to large-scale works or pathos-laden chiaroscuro, is further heightened by the relaxed pose of the man who smiles so courteously at the spectator.

On closer inspection, however, the look on his face appears to turn almost imperceptibly into supercilious sarcasm, and what seemed at first to be candour becomes an impenetrable expression. The cool blue tones of the painting enclose the artist in a hermetic world of precious artificiality that is neither vulnerable nor accessible. Light as the colours may be, the painting itself contains no light.

Strangely static, as though unaffected by any change in light conditions, it denies the fleeting aspect of fresh and spontaneous drawing. The pastel chalk does not simply portray the powder of the wig – it is the powder, and its dull, matt sheen is the sheen of velvet. Distance and intimacy alike are evident in La Tour's pastels.

Portrait of Mme de Pompadour, 1755

The Rhinoceros

Oil on canvas, 62 x 50 cm
Venice, Ca' Rezzonico

b. 1702 Venice
d. 1785 Venice

Like other Venetian painters of the Rococo, Longhi studied in Bologna, first under Antonio Balestra, then under Crespi. In about 1730 he was back in Venice. He was not successful, either with his early historical paintings nor with his religious works, so, from the 1740s, under Crespi's influence, he began to paint mainly genre pictures recording Venetian life. In the manner of Watteau and his successors he created a personal form of conversation piece, depicting fashionable Venetian society with a fine, wry irony. In 1756 he became a member of the Academy, where he taught from 1758 to 1780. The affinity between Longhi's genre pictures and Goldoni's comedies (Longhi had contacts with him) is often pointed out, and rightly so. Longhi was also a considerable portrait painter.

In 1751, a rhinoceros was exhibited in Venice which had previously been put on show in Nuremberg, Stuttgart and Strasbourg. Longhi shows us some of the visitors who attended this spectacle standing on and before a wooden platform, in front of which the rhinoceros is eating its hay. Yet none of the guests is actually looking at the monstrous animal. The elegant lady in the lace shawl is looking straight at the spectator; her dark suitor, like the servant to her right, is staring ahead of him; the man at the edge of the picture with the clay pipe is deep in thought; the woman in the green shawl is looking towards the other side and her neighbour is gazing out of the picture through a black mask. Not even the little girl shows the slightest sign of astonishment. All of them seem to be caught in a rigid pose of supposed vitality, unreal behind their masks and physiognomies.

They seem like quotations of a Venetian life that is no longer within them, but only presented to them. And in front of this silent display of detachment stands the rhinoceros in its bulky and ponderous simplicity, painted with a certain naivity and described by the poster on the wall as *Vero Ritratto di un Rinoceronte.* It is the "veritable portrait" of this animal which, in its strangeness, is the only reality. The familiar Venetian world behind it, has become the truly unfamiliar, because it is merely a shell, a costume, a mask or shadow of the reality to which it is no longer able to return a sense of wonder.

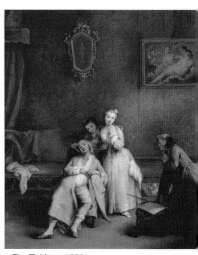

The Tickle, c. 1775

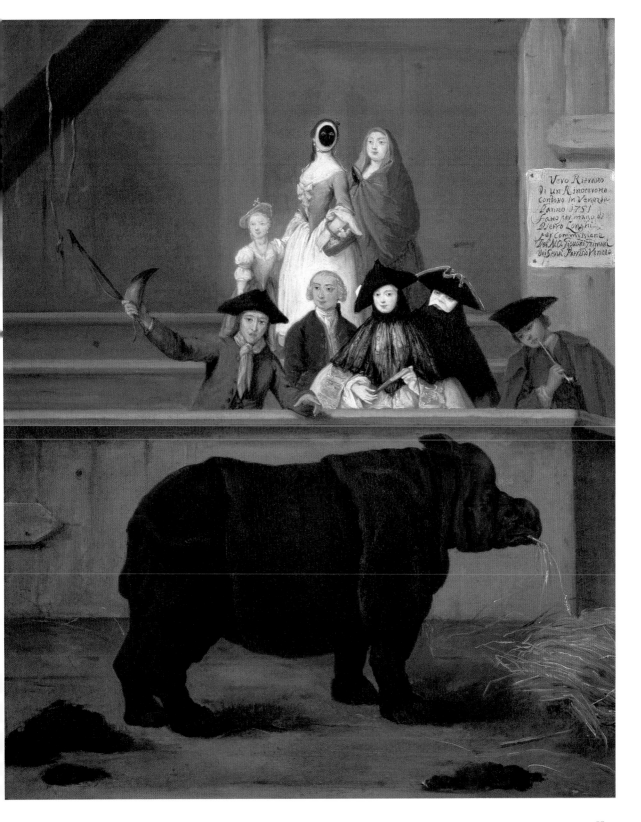

Blonde odalisque (portrait of Louise o'murphy)

Oil on canvas, 59 x 73 cm
Munich, Bayerische Staatsgemäldesammlungen, Alte Pinakothek

In the salon reports of the *Nouvelles Littéraires* for the year 1750, Boucher is chided for painting "women's heads more pretty than beautiful, more vain than noble". Such criticism is vindicated in the portrait of Louise O'Murphy, a young Irish woman who worked as Boucher's model and who, in 1753, was briefly the mistress of Louis XV. The artist does not present her as a Venus of classical beauty, but portrays her instead in a provocative pose of unambiguously erotic persuasion as a sweet child-woman.

In spite of the high esteem in which Boucher was held by the public of the day, they frequently criticized the artificiality of his "porcelain heads" and his delicately coloured interiors. Here, too, his handling of colour is delicate in the extreme, creating a powdery surface without depth in which which the hues are brought together by the use of white as a common ground. There are neither deep shadows nor sombre contrasts of light and shade. The white ground also takes the edge off the primary triad of red, yellow and blue, diluted here to discreet shades of pink, pale yellow and light blue. The unapproachable, aloof beauty is dethroned and a pretty little coquette is put in her place.

Everything seems to be in the foreground, like the pose of the mistress, and is nevertheless beyond reach of the spectator. The body that seems to be offered in such proximity, is not really present, but transported by the artificiality of the surface. The young girl's willing charms are paraded as attributes of naive beauty rather than as an appeal from within the painting.

The artificiality of the colouring emphasizes the hermetic pictorial world governed by its own rules. Her pose of langorous waiting is not intended for the spectator. The pictorial space merely gives us an envious glimpse into a room whose door remains closed. Boucher does not destroy the sense of anticipation by allowing the figure she is waiting for to appear, but heightens it by the very fact that nothing happens. No person and no action stand in the way of indulging in these seductive charms – only the boundaries of the picture.

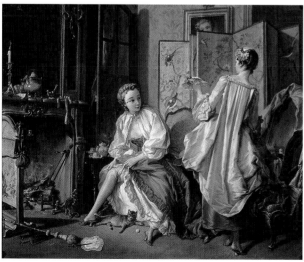

The Toilette, 1742

"Boucher has all the talents that a painter can have, and succeeds on a large scale and in detail. No painter of our day can match his grace, but he just paints for money and thus undermines his talent."

Denis Diderot

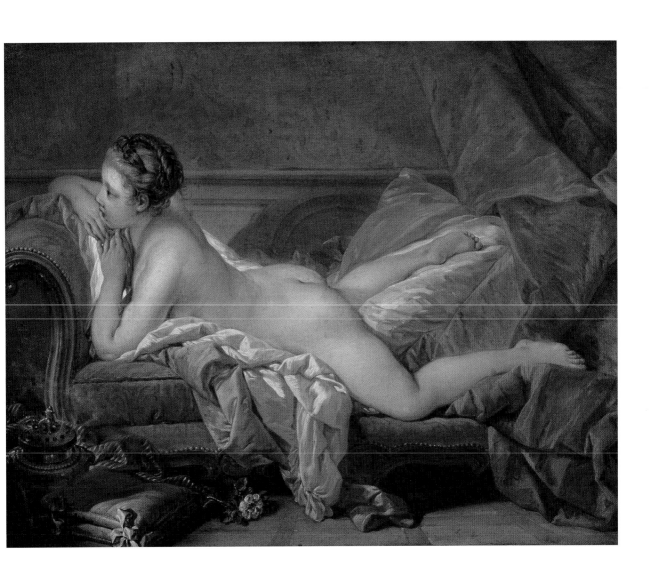

Rinaldo and Armida

Oil on canvas, 104.8 x 143 cm
Würzburg, Staatsgalerie

Gerusalemme Liberata (Jerusalem Liberated), the great heroic epos by Torquato Tasso (1544–1595), published in 1581, not only inspired Tiepolo to create his series of paintings in the Tasso Hall of the Villa Valmerana near Vicenza, but also to create individual portrayals such as this one. The episode involving Armida and the hero Rinaldo is set in the days of the crusades.

The enchantress Armida, resting after the rigours of battle, recognizes him as an enemy and is about to slay him. But at that moment, her hate turns to love and she bears him away to an enchanted island far from war, where Rinaldo is caught in the spell of her love. Two warriors sent to look for him make him aware of his error by holding up a shield as a mirror, reminding him of the battle, and take him back with them.

Tiepolo's Armida is a magnificent Venus figure carrying a mirror as the instrument of her magical powers and accompanied by Amor as the bringer of love. The young hero rests devoted at her breast, weating a garland of flowers as the sign of his entanglement. The theatricality of the foreground scene is heightened by the background scene in which, behind a "backdrop architecture" we can see the two warriors approaching. The wealth of colour, the sensual charms of Armida, the devotion of Rinaldo, the statue of a satyr and the parrot, the pale blue landscape behind the gate, the shimmering pink of the sky, the fantastic trees all conjure up the atmosphere of an *Ile enchantée*.

A sense of duty, reality and order is embodied in the figures of the two soldiers who wish to draw Rinaldo back to their world. By investing all his painterly powers of conviction to mediate an episode of happiness, Tiepolo succeeds in drawing us, the spectators, into the spell: we, too, are beguiled by Armida; only in the distance do we perceive the warning of the vassals, the voices of everyday life. This scene of Tasso's lovers has been condensed to an exemplary form in which the victory of magic over reality becomes a quietly menacing actuality.

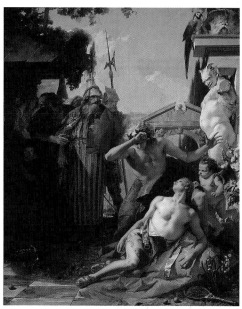

The Death of Hyacinth, 1752/53

"Tiepolo produces more in a day then Mengs in a week."

J. J. Winckelmann

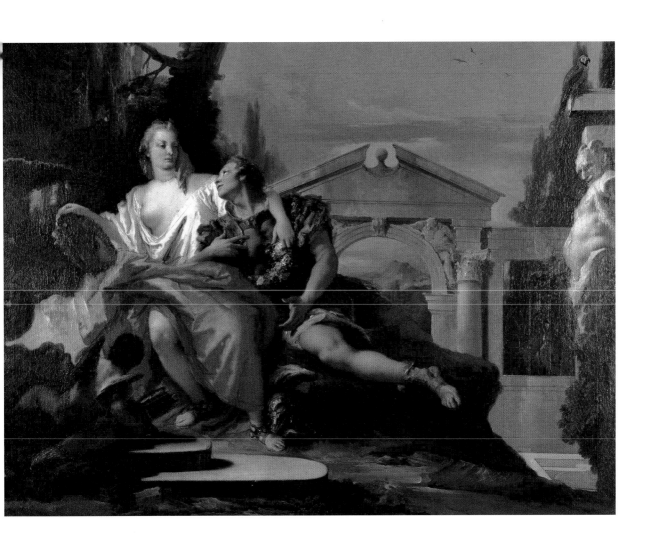

The Nymph as symbol of Nymphenburg

Ceiling fresco (detail)
Munich, Schloss Nymphenburg, Steinerner Saal

b. 1680 Gaispoint (near Wessobrunn)
d. 1758 Munich

Zimmermann grew up in the arts and crafts milieu of Wessobrunn, which is famous for its school of stucco-work. He received his training as a painter in Augsburg. It appears that he worked as a stuccoer until 1720. As a fresco painter he often collaborated with his brother Dominikus, an architect (e.g. of the church at Steinhausen near Lake Constance, 1730/31). While in other European countries fresco-painting was already in decline in the first half of the 18th century, it still flourished in southern Germany. Belonging to the same generation as Asam, Zimmermann (with his brother) was the leading master of the early Bavarian Rococo.

In his ceiling decorations he abandoned the illusionist element and introduced terrestrial zones around the edges so that the open vault of heaven is framed by bucolic or idyllic landscape scenes (Hofkirche St Michael in Berg am Laim, Munich, 1739; Great Hall in Schloss Nymphenburg, Munich, 1757). Architectural elements, ornament and picture merge along the borders. The high point of his art is the decoration of the Wieskirche, one of his brother's late works, where Zimmermann achieved an overall perfection in his handling of colour and design.

In his last work, the ageing Zimmermann created an image of tremendous atmospheric power. It is finely balanced in terms not only in its composition but also in its coloration. This ceiling painting as a whole presents an allegory of flourishing welfare as a source of peaceful contentment, in harmony with the world of the gods. In the main view, the beautiful nymph appears in a charming Arcadian setting. She is enthroned on the steps of a garden architecture flanked on the right by an overgrown arched pergola and on the left by a fountain with a rocaille ornament.

Only a thin white veil cloaks the hips of the naked nymph and on her breast she wears a little blue cloth as an indication of the traditional colours of Bavaria: white and blue. A reed-crowned nymph brings her a shell heaped with pearls and corals, the fruits of the sea, while another female figure hands her a basket of blossoms. Just as these two figures embody the elements of water and earth, and just as the fountain suggests water and the foliage suggests earth, the nymph too belongs to both spheres. Nymphenburg Castle with its fountains is presented as a man-made idyll. The entire complex is interpreted as a vast nympheum in which the boundaries between the elements are dissolved.

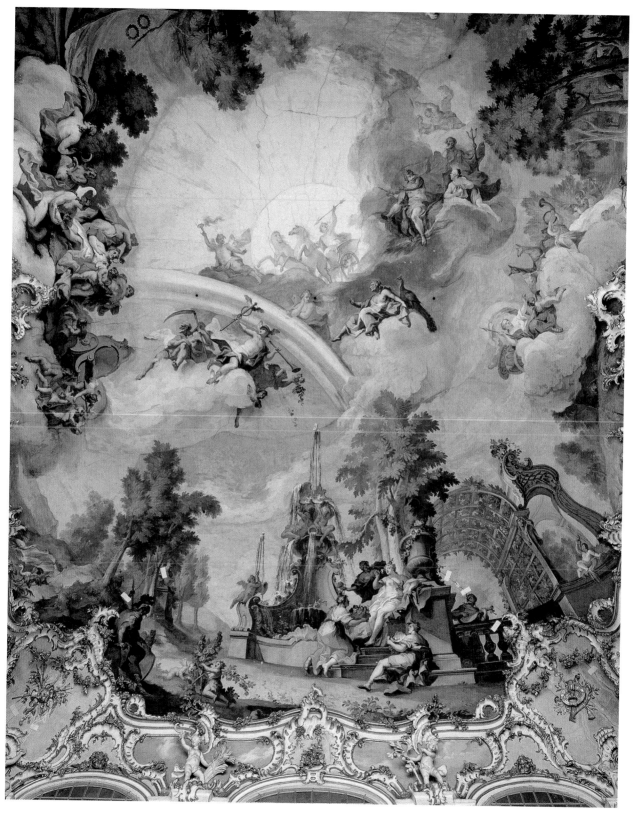

тhe Apotheosis of st Benedict

Ceiling fresco
Rott am Inn, Benedictine Church

b. 1705 Tritschengreith
(Upper Bavaria)
d. 1788 Haid (near Wessobrunn)

After basic instruction in Murnau, Matthäus Günther became the pupil and assistant of Cosmas Damian Asam. He had no direct contact with Johann Evangelist Holzer, who was his junior, but he acquired out of his estate various drawings and can be considered his legitimate artistic successor. He was made master in Augsburg in 1731 and subsequently worked as an independent fresco painter. In 55 years he decorated over sixty rooms. His main works were produced in the Benedictine churches at Amorbach and Rott am Inn, the Augustinian Canonical churches at Indersdorf and Rottenbuch, the parish churches at Sterzing, Mittenwald and Oberammergau, and the Great Hall at Sünching castle. Günther worked in Bavaria, Swabia, Franconia and the Tyrol and can be considered as one of the most important representatives of south German fresco painting.

With his domed ceiling fresco in the monastic church of Münsterschwarzach, Johann Evangelist Holzer supplied the stylistic, compositional and contentual model for Günther. It was Holzer's pioneering achievement of finding an individual form of expression in a time of stylistic change that forged the link between Rococo and Neoclassicism. At Rott am Inn, Günther dispenses with Holzer's technique of architectural illusion. The real architecture is no longer continued into the painting, nor does it open up to a celestial illusion. The ceiling painting is like an easel painting projected onto the ceiling, avoiding exaggerated *sotto in sù* views from below.

As early as 1761, Mengs had already applied this Neoclassicist version of ceiling painting in the Roman Villa Albani. The detail from the overall painting which shows the Holy Trinity in the centre, presents the founders of the Benedictine order on concentrically aligned banks of clouds, with the angles bearing the symbols of his life – chastity, continence, survived assassination attempt (the poisoned chalice alludes to this) and the rules of the order. What is new here, and characteristic of Günther, is the predominantly grey colouring that replaces the bright colours of Asam and Zimmermann and heralds the advent of Neoclassicism.

The Virgin as Intercessor for Humanity, 1754/55

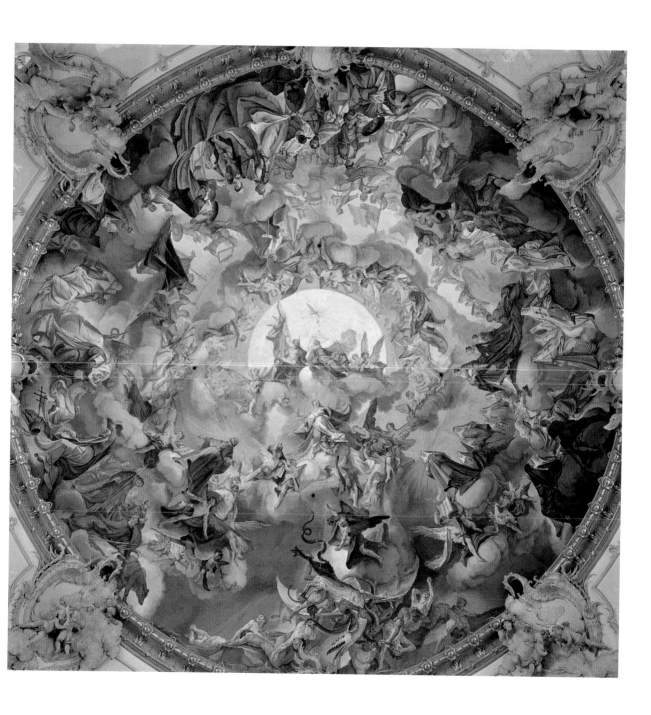

view of snowdon from Llyn Nantlle

Oil on canvas, 100 x 127 cm
Nottingham, Castle Museum and Art Gallery

b. 1714 Penegoes (Wales)
d. 1782 Colommendy (Wales)

Wilson was a pupil of Thomas Wright in London and, like his master, specialised in portrait painting to begin with. His visit to Italy (1750–1758) took him first to Venice, then to Rome. While in Italy he decided to abandon portrait painting for landscape, later becoming the first great British landscape painter. The principal sources of his inspiration were Poussin, Lorrain and Vernet, and he also owed something to Dutch landscape painting of the late 17th century. Among his finest works are his English landscape and Welsh mountain scenes, which are executed with topographical accuracy and show great skill in composition and a finely graded palette in the way they convey the expanse and peace of the lakes and hills.

Paintings such as this were of seminal importance to the otherwise apparently unprecedented art of William Turner. Here, Wilson abandons the tradition of Poussin or Vernet and dispenses with the evocative power of pictorial objects.

He composes his landscape entirely in blues, greens and browns linked together in finely transparent shading. The atmosphere carries itself and no longer depends on individual pictorial components as its vehicle. The outlines of the mountains, trees, and shoreline, and the mirror image on the water, create their own system of movement and counter-movement that requires no stabilizing compositional techniques.

The same applies to the density and restraint with which colour is handled; even in the colour composition, the artist does not use the tectonic structure of chiaroscuro. The gentle tones complement each other without blurring. The landscape itself has neither drama nor passion. Cool, sometimes with the precision of a draughtsman, he captures it as a phenomenon that lives not by tension, but by the self-evident fact of its existence. Landscape is no longer stage, a place of action, but a detached "opposite number". It becomes comprehensible only when we penetrate the many layers of its atmosphere slowly and cautiously.

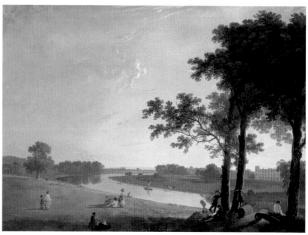

View of Syon House across the Thames near Kew Gardens, c. 1760

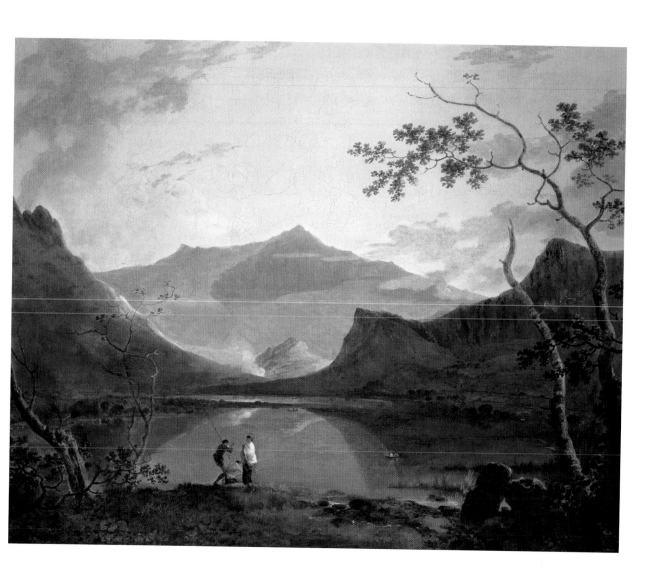

portrait of Rebecca Boylston

Oil on canvas, 127.9 x 102.2 cm
Boston (MA), Museum of Fine Arts, Bequest of Barbara Boylston Bean

b. 1738 Boston
d. 1815 London

After the death of his father, a tobacco merchant of Irish descent, Copley first received instruction from his stepfather, the etcher Peter Pelham. As a painter Copley was largely self-taught, studying copies of old masters and also printing techniques and using all available sources of contemporary European painting. In his early twenties he was already a popular portraitist, receiving commissions from New York, Philadelphia and Canada. From 1765 onwards he exhibited in London, where his work was well received by his fellow painters. Following West's invitation, he at last visited England himself in 1774 to perfect his technique. His travels on the Continent were short but intensive. When in London he painted several striking historical pictures, including *Brook Watson being attacked by a Shark* (Boston, Museum of Fine Arts, 1778), whose topicality had a revolutionary effect. He was made an associate (1775) and then a full member of the Royal Academy (1783). Around this time he began to align himself more with European conventions, a tendency which became more pronounced with advancing years.

The woman who commissioned this portrait was already forty years old and, in her day, would have been considered an old maid – although, as a sister of the enormously wealthy Boston merchant Nicholas Boylston, she would undoubtedly have made a good match. Copley, an experienced portraitist, handled the task with panache. With-out seeking to give this confident woman a look of youth that would have defied all credibility, he concentrates on her charming vitality. She sits for the artist, dressed in a silken negligée. This is intimate garb indeed.

In France, only the aristocracy had their portraits painted in such apparel. Yet it is the prerogative of the bourgeois Rebecca Boylston to adopt this dress as a sign of her confidence and imperturbable dignity. The thin fabric also gives Copley a chance to emphasize Rebecca's slender figure, showing her firm and youthful breasts beneath the satin sheen. At the same time, in the intelligent and slightly mocking gaze of her dark eyes, Copley suggests that this is a woman of experience. Six years later, Rebecca married a wealthy landowner who commissioned Copley to paint a second portrait of his beautiful wife.

The fact that Copley did not portray his model in the stiffly prestigious setting of a salon, but in a park, further underlines the natural charm of this millionairess. There is nothing contrived or affected in the way she holds the little basket of rose blossoms in her hands; it is almost as though she had just picked the flowers in the famous gardens of the Boylston villa. The slightly cramped Rococo attitude of Copley's earlier paintings succumbs here to a new and distinctly American directness and spontaneity.

> **"I am desireous of avoideing every imputation of party spirit, political contests being neighther pleasing to an artist or advantageous to the Art itself."**
>
> John Singleton Copley

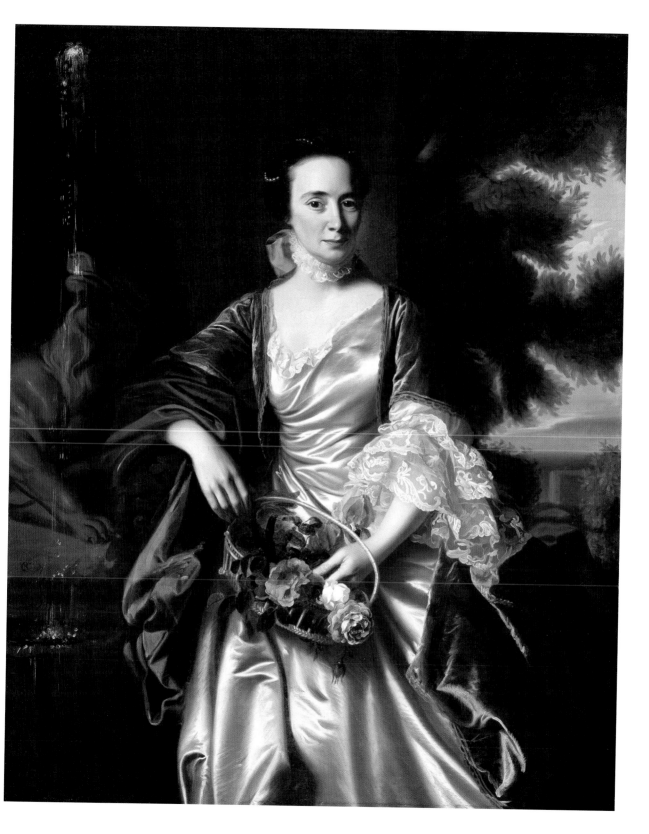

The swing

Oil on canvas, 81 x 64.2 cm
London, The Wallace Collection

b. 1732 Grasse (Provence)
d. 1806 Paris

Fragonard was the son of a glove-maker and tanner. He came to Paris in his childhood. At first he worked as assistant to a lawyer who noticed his artistic talent. In 1747 he was given instruction by Chardin, and a year later was accepted by Boucher who had insisted on prior grounding. Boucher entered him for the Rome 1752 competition, which he won. Fragonard then studied three years at the *Ecole des élèves privilégés* under van Loo, concentrating in particular on the Dutch masters, before being accepted by the Académie de France in Rome. He travelled through Italy and on his return to Paris became a member of the Academy. He soon resigned, however, as the membership – he had entered the Academy as an historical painter – evidently did not suit his artistic interests and social tastes. Between 1765 and 1770 his subject matter was frequently of an amorous-erotic nature. Fragonard was not very successful with prominent givers of commissions, such as Madame Dubarry. Fragonard remained a brilliant colourist to the end. Works such as the *Love Vow* (Orléans, Musée de Peinture et de Sculpture) or *Sacrifice of Roses* (Buenos Aires, Museo Nacional de Arte Decorativo) show the pathos of a monumentalised passion in the Classicist manner. Under David's protection he survived the turmoil of the French Revolution, but the new generation, in particular the Empire period, had no use for his aesthetics, which were still rooted in the Rococo. He had to leave his residence in the Louvre in 1806 and died in the same year, almost forgotten.

"Balance" is the French word for a swing. And balance is certainly the main theme of this painting, so typical of the era. After all, Rococo itself was one great balancing act, constantly teetering on the brink of a fall from its bold flights of grace. Here, too, the artist elegantly balances on the knife-edge of danger. The incident is unequivocal, but intention takes the guise of accident. The young suitor lies at the foot of a stone monument – incidentally crowned by Amor, the god of love – as though he had accidentally stumbled and fallen in the bushes, where, as though by chance, he catches a glimpse beneath the rustling petticoats of the pretty woman in the swing. Yet the scene shows more than a flirtatious play between voyeurism and exhibitionism. The face of the young man lying amidst the roses is illuminated as though by some invisible source of light – like a saint in the face of a celestial vision. However, it is not divine truth that reveals itself to him, but something much more human: what he glimpses is heaven on earth, and the joys it promises are of a very worldly nature.

The painting was originally commissioned by a wealthy baron in homage to his beloved. Yet Fragonard expresses more than a lover's devotion and the beauty of his beloved. The pretty woman's gaze is expressionless, and her eyes seem glazed in the charming blush of her face. What is happening here is already symbolized by the swing reaching the highest point in its arc. In a moment, it will fall again, drawn back by the elderly man in the dark background: a split second of erotic rapture, as blissfully lascivious and imperilled as Rococo itself.

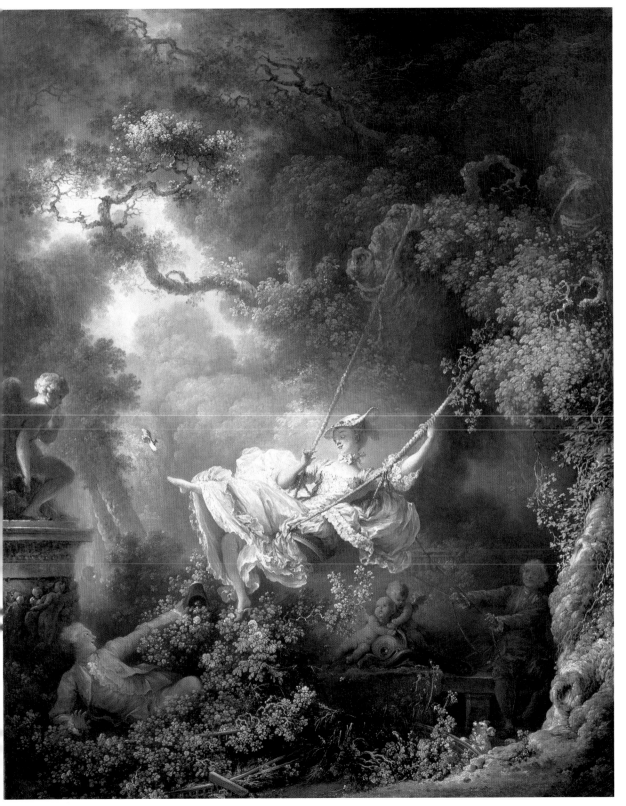

An Experiment on a Bird in the Air Pump

Oil on canvas, 183 x 244 cm
London, The National Gallery

b. 1734 Derby
d. 1797 Derby

Wright studied under Thomas Hudson in London. In 1771 he became a member of the Society of Art and in 1784 of the Royal Academy. A visit to Italy, 1773–1775, gave him the opportunity to study the old masters. Caravaggio and his followers seem to have fascinated him particularly, as shown in his later work with its dramatic light contrasts. On his return to England he tried briefly to set up a portrait practice in Bath, but then went back to Derby, where he remained. Although primarily a portraitist, he also worked on his discovery of the scientific genre painting. He developed an understanding of how to refine the effect of lighting in order to bring emotion into an apparently objective atmosphere. In landscapes, too, he was innovative in his use of light sources.

Most of Joseph Wright's paintings explore the effects of light and illumination. He counted amongst his close friends a number of factory owners and scientists, the very people who were the driving force behind the changes that came with the dawn of the industrial age, which was to bring so much profit and wreak such disaster. He was fascinated by mankind's encounter with technology, innovation and invention, and with the myth of a new era which he monumentalized in his paintings. The light that Caravaggio used to project his revelations and celestial visions seems to have fascinated Wright as well. But the spectator soon realizes that any similarity is misleading. In the work of Caravaggio, the source of light remains unknown so that it seems almost supernatural. Wright, on the other hand, uses light for dramatic effect. The experiment carried out by the elderly, long-haired scholar thus becomes an exciting theatrical scene.

The scientist is demonstrating the principle of the vacuum. Using a pump, he has emptied the glass sphere of air, creating a vacuum in which a bird seems to be struggling to gasp its last breath. Pained, the little girl turns her face away as though witnessing the martyrdom of a saint. Here, we find religious iconography being used to portray a worldly situation, elevating the scientific experiment to a para-religious event.

View of Vesuvius from Posillipo, undated

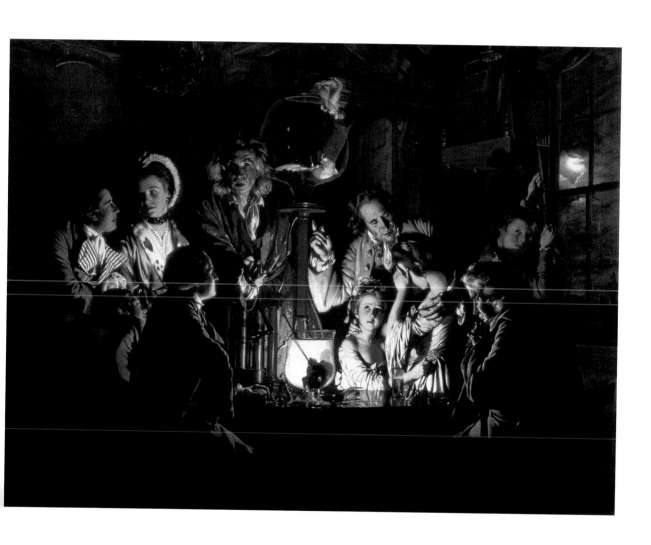

тhe Lamentation of тime Passing

Oil on canvas, 79 x 61 cm
Munich, Bayerische Staatsgemäldesammlungen, Alte Pinakothek

b. 1725 Tournus (Sâone-et-Loire)
d. 1805 Paris

Greuze was the sixth of nine children. His father was a slater and wanted to have his son trained as an architect. But the son's talent won, and in 1749 he was sent to Lyon to study under the painter Charles Grandon. In 1750 Greuze went to Paris, and from 1755 studied at the Academy under Natoire. He spent two years in Italy, but this visit left no deep impressions. With his moralising genre pictures Greuze satisfied public taste, which had undergone a change and had grown tired of the Rococo manner.

Subjects such as *The Cheated Blind Man*, *The Paralytic Served by his Children*, *The Much-Loved Mother*, *The Ungrateful Son* and *The Chastened Son* found favour with the influential critic Diderot, who called this kind of painting "peinture morale", and so greatly contributed to Greuze's success. A parallel in the literary world could be found in the works of Jean-Jacques Rousseau. Although received by the Academy on the strength of an historical painting, he was categorised as a genre painter which disappointed him. His genre paintings gradually assumed heroic elements normally found in historical painting. Today he is held in high esteem as a portraitist.

"Let morality speak in painting" demanded the great critic Denis Diderot in 1763 and he saw this wish fulfilled in the works of Greuze. Today, especially in a painting such as *The Lamentation of Time Passing*, we see a delicately erotic image cloaked in a thin veil of moral piety.

The seeming contradiction is resolved if we interpret Diderot's concept of morality correctly. He was not calling for a total ban on the portrayal of sensual charms, but demanding a pictorial message or statement that was not restricted merely to a presentation of the erotic, in the manner so consummately mastered by Jean-Honoré Fragonard. His knowledge of Dutch and Flemish engravings gave Greuze the iconographic vocabulary with which to construct his pictorial narratives. The watch in the hand of the child-like young woman is a traditional symbol of transience and the fleeting ephemerality of a brief amorous adventure which is described here as false happiness.

Greuze's achievement lies in the way he has made the attractively half-bared breasts the "eyecatcher" around which he structures the narrative suggested by the title; we see the unmade bed, the loosened blouse, the abandoned handicraft, the scattered belts and bands, the discarded cap and, above all, the letter – the lover's letter of goodbye.

"greuze is an excellent artist, but a totally impossible person. one should collect his drawings and pictures, and leave the man alone".

Denis Diderot

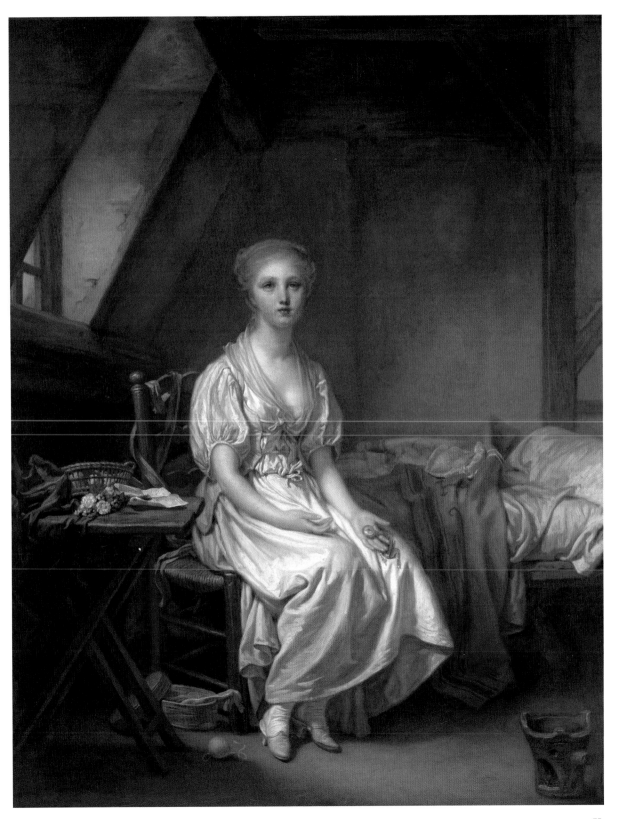

colonel Guy Johnson and captain David Hill

Oil on canvas, 202 x 138 cm
Washington (DC), National Gallery of Art, Andrew W. Mellon Collection

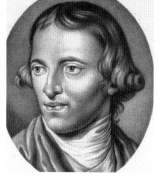

b. 1738 Springfield (Pennsylvania)
d. 1820 London

West began his career as a portrait painter in Philadelphia and New York. One of his sitters persuaded him to try his hand at history painting, and the result was the *Death of Socrates* (Nazareth, Pennsylvania, Stites Collection), his first attempt in this field. Patrons enabled him to visit Rome by granting him a scholarship, the first American artist to be helped in this way. There he found a new patron in Cardinal Albani. He joined the circle of leading artists gathered in Rome and became friendly with Mengs and Johann Joachim Winckelmann. He was appointed as a member of the Academy, both in Florence and Parma.

On his intended return journey to America he stopped off in London in 1763 and remained there for the rest of his life. He had a brilliant career, becoming a founding member of the Royal Academy in 1768 and historical painter to the royal court in 1772. West was also a respected teacher, especially of fellow American artists in London, including Copley, Trumbull, Sully, Stuart and Pratt.

It is no coincidence that Benjamin West should have enjoyed his greatest success in London. As this example demonstrates, he succeeded in uniting the great tradition of 18th century English portraiture with a reawakened interest in history painting. His particular appeal in the eyes of an English public lay in the fact that he did not use the historical situation to magnify the dignity of the sitter to the point of hero-ism, and did not stylize the figure of the colonel into a monumenta bearer of history.

Colonel Johnson is shown in a relaxed pose, with an Indian cloak draped over his uniform and moccasins on his feet. Behind him in the half shadow, stands an Indian chief who is smiling down on the seated man and pointing out, with a gesture of his left hand, the peaceful existence of his tribe, visible in the background. The fresh clear face of the colonel, the Indian attributes and the chief himself al suggest a love of liberty without violence, and a sense of honest anc egalitarian cooperation.

The portrait was to become the emblem of a new belief in liberty, expressed by the natural pose and friendly, relaxed attitude of the figures which indicate that liberty is no longer an unattainable and life-less ideal, but something that comes to life in those who practise it.

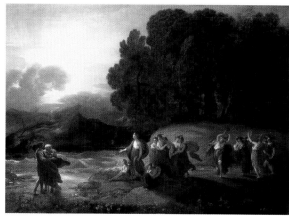

The Meeting of Telemachus and Calypso, undated

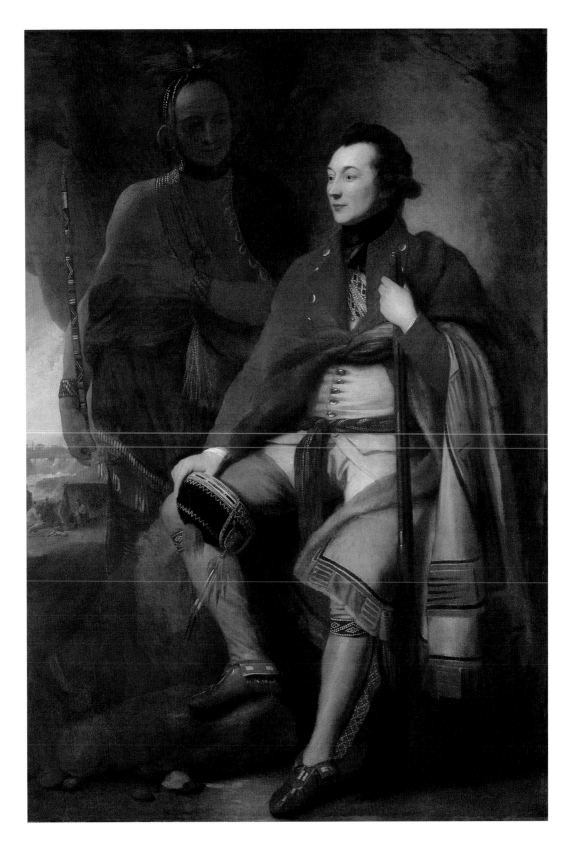

portrait of a young woman

Oil on canvas, 130 x 102 cm
Frankfurt am Main, Freies Deutsches Hochstift – Frankfurter Goethe-Museum

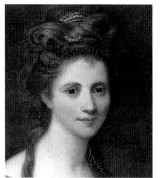

b. 1741 Chur (Switzerland)
d. 1807 Rome

Taught by her father, a Vorarlberg painter, Angelika Kauffmann already painted remarkable pastel portraits at the early age of 15. On extensive Italian travels she developed a thorough knowledge by copying the old masters. She became a member of the Academies of Florence and Rome, and her meeting with Johann Joachim Winckelmann was decisive in pointing her in the Classical direction. From 1766 she lived in London for 15 years, becoming a Royal Academician and working with the architect Robert Adam, amongst others. On her return to Rome she became the centre of a salon which Goethe and Herder attended. Her portraits owe much to Reynolds and Mengs, while her Classical religious and mythological pictures were based on the study of Antiquity seen with the eyes of Winckelmann.

Even at the age of eleven, she earned admiring praise for her portrait of Bishop Nevroni and although she would later concentrate on allegorical, antique, historical and religious themes in her paintings, the portrait was to remain the driving force behind her success throughout her life. She received so many commissions that her painting tended to become rather routine, taking on an increasing smoothness and superficial appeal at the expense of a more distinctive style. Goethe, whose portrait she painted in 1787 merely commented laconically: "A fine looking youth, but not a trace of me." This portrait by the artist Angelika Kauffmann also has something routine about it, and is as pleasingly decorative as any interior decor that she might have created in her frequent collaboration with the English architect Robert Adam. Nevertheless, it does show a face as that of a highly sensitive personality. It is interesting to note that she illustrated Klopstock's *Messias* and that she frequented poets of literary sensitivity, such as Goethe, Herder, Winckelmann and Reynolds, which may explain this half natural, half artificial pose. On the other hand, there is something clear and decisive about her traits, which would certainly conform to Kauffmann's reputation as a draughtswoman. In her drawings, she presents a bold, free and "modern" technique that has all the distinctive individuality of real talent.

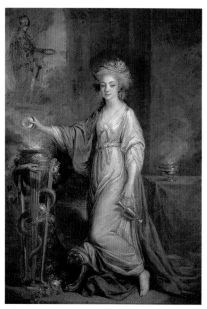

Portrait of a Woman as a Vestal Virgin, undated

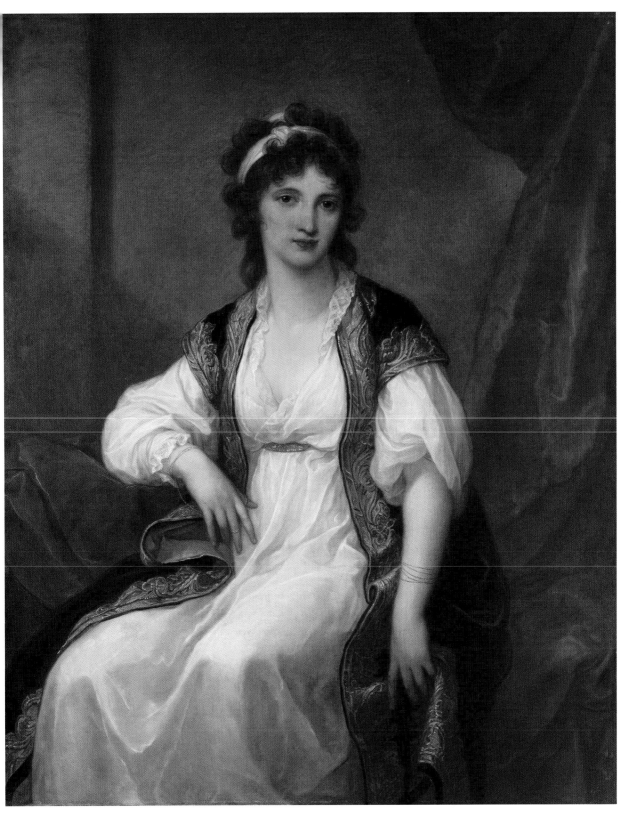

The Infant Samuel

Oil on canvas, 89 x 70 cm
Montpellier, Musée Fabre

b. 1732 Plympton (Devonshire)
d. 1792 London

Reynolds was the son of a clergyman and was sent at the age of seventeen to study under the popular portrait painter Thomas Hudson in London. For some years he worked in his teacher's somewhat dry style in Plymouth, London and Devonport. His meeting with William Gandy (Gandy of Exeter) inspired him to adopt a new technique and a more fluid style, probably influenced by his study of Rembrandt. He went to Rome via Lisbon and Algeria with his patron Admiral Keppel, where he was particularly impressed by the works of Raphael and Michelangelo. Here he produced his famous *Caricaturas*, portraits of English visitors to Rome. He returned by way of Florence, Parma, Venice and Paris to London, where he settled in 1753. Here he painted a portrait of Keppel depicted in the pose of the *Apollo of Belvedere* after a shipwreck (Greenwich, National Maritime Museum). Through the use of such citations and dramatic events Reynolds attempted to elevate portraiture to the level of historical painting.

In 1768 he was appointed president of the newly-founded Royal Academy. In his *Discourses*, given annually at the awards ceremony, he presented the theory of the Grand Manner, that art must be more idealistic than realistic. His contact with Gainsborough, who came to live in London in the 1770s, remained loose, probably because of their difference in temperament. His last visit to the Continent in 1781, mainly devoted to the study of Rubens' works, also took him to Antwerp and Düsseldorf, amongst other places. Reynolds, who was knighted in 1769, was one of the great British painters of the 18th century and influenced generations of portrait painters.

Reynolds never tired of encouraging his students at the Royal Academy to bear in mind how important it was to study the contents and techniques of the old masters and, by copying them, to develop a style they could use. Though Reynolds himself was a highly distinctive painter, he mastered "à-la-mode" painting and could effortlessly slip into the guise of another style.

Here in his portrait of *The Infant Samuel*, the stylistic guise he dons is that of Rembrandt. In earthy shades of brown, he shows Samuel, the last judge and first prophet of Israel, as a child. The very choice of theme is unusual, considering the role of Samuel as the epitome of constant obedience, great wisdom and just but firm rule, a weighty role indeed for a child of such tender age, as Reynolds shows here. By using the light and colours of Rembrandt, he also cites the profound human piety of the Dutch artist's œuvre. In this way, the Rembrandtesque becomes a motif of dignity that not only enriches the painting and lends it profound significance, but also mediates between the religious Old Testament theme and the innocence of the child. The Rembrandtesque brown is also a gallery tone that makes the painting a collector's piece. In this context, the childishness also functions as mediating distance: the high religious theme becomes more adaptable and less pathos-laden. It becomes a *Samuel* that can hang in any home.

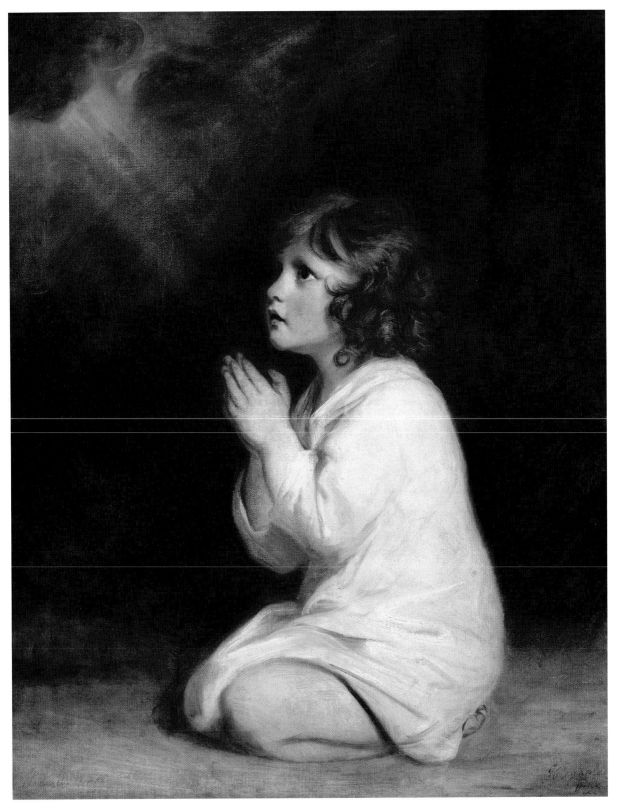

venetian gala concert

Oil on canvas, 67.7 x 90.5 cm
Munich, Bayerische Staatsgemäldesammlungen, Alte Pinakothek

b. 1712 Venice
d. 1793 Venice

Guardi obtained his initial training at the workshop of his older brother, together with whom he also seems to have worked later. As a veduta painter he took as starting point the work of Michele Marieschi and Canaletto, while his figure painting owed something to Magnasco and Tiepolo, the Guardis' brother-in-law. Like Canaletto and Bellotto, Guardi took his veduta production abroad, where the demand was, primarily the English art market. But he increasingly moved away from mere topographical rendition and towards a poetical view, in which Venetian effects of light are used to convey mood. His sensitive brushwork sets off the shimmering air and reflections of light on water, making the objects in the picture tremble and vibrate.

Besides this, Guardi was also engaged in figurative painting, but it was not until mid-century that he carried out independent commissions. Around 1770 he painted the twelve-part series *Feste dogali*, in which he depicted Venetian state ceremonies. Francesco, whose work is sometimes not easy to distinguish from his brother's, was also a graphic artist. His work in this field has a captivating spontaneity, and belongs among the best produced in the 18th century.

Grand Duke Pavel Petrovich, later Tsar Paul I, and his wife Maria Fyodorovna, arrived in Venice in January 1782, providing a welcome occasion for a city so fond of festivity to stage a number of brilliantly lavish celebrations and spectacles in their honour. The elderly Guardi was commissioned to chronicle their visit. He documented the ball at the Teatro di San Benedetto, the ceremonial procession on the Piazza San Marco, the regatta, bullfight and banquet. The artist, too, welcomed such an opportunity. Just as his distinctive drawings with their bold and vibrantly moving brushwork paid little heed to faithful detail in rendering palaces, towers, obelisks or figures, so too is his documentation of the royal visit hardly the work of a painstaking collector of data.

The gala concert in the philharmonic hall of the Procuratie Vecchie with a women's choir and a women's orchestra in the gallery, the shimmering silk robes in the warm candlelight, the glittering chandeliers, the gleaming mirrors and the vermilion floor all merge to a floating image of serene enchantment. The timelessness of the celebration and its carefree *joie de vivre* are the legitimation for Guardi's painting. We cannot actually make out who exactly is the grand duke or his wife, for the artist did not create any individual physiognomic portraits. In the midst of celebration, the contours of all the individuals and the reality of time itself dissolve. In place of the strict regulated ceremony of the Baroque, what we see here is unceremonial; a choreography of coincidence has supplanted hierarchy. Whereas, in earlier times, the solemnity of the occasion would have been highlighted by contrast and difference, juxtaposing the wealthy with the less wealthy, the magnificent with the less magnificent, the highly esteemed with the less highly esteemed, these festivities gain their radiance from their sheer indissolubility; the celebration becomes a *Gesamtkunstwerk*.

In Guardi's painting, the light does not add brilliance to any individual person; it is diffuse. Nor are there any accents of colour that might serve to emphasize any individual. In dissolving the bounds of individuality and sensual perception we find a technique suited to escape from a sense of reality. Guardi's painting uses compositional technique s to express this illusion of an extended existence in which the participants taste immortality for a few hours.

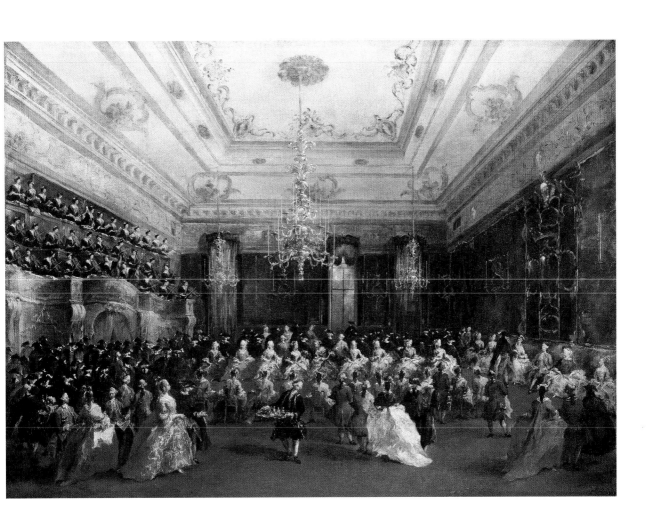

The Morning walk
(Mr and Mrs william Hallett)

Oil on canvas, 236.2 x 179.1 cm
London, The National Gallery

b. 1727 Sudbury (Suffolk)
d. 1788 London

Gainsborough was the fifth son of a well-to-do cloth manufacturer. Because of his early talent for drawing he was sent to London at the age of thirteen. There he studied etching under the Frenchman Gravelot, a pupil of Boucher. Apart from being influenced by the French Rococo, to which he was introduced by Hayman at St Martin's Academy, Gainsborough's landscapes were particularly affected by 17th century Dutch landscape pictures which he had copied and restored in his early years. Between 1747 and 1759, in Sudbury and Ipswich, he produced this type of landscape as well as working in the style of the French pastoral idyll. In 1746 he secretly married Margaret Burr, the illegitimate daughter of the Duke of Beaufort, which ensured him financial independence.

While the pure landscape was not highly appreciated in England, Gainsborough succeeded in combining full-length figure portraits with landscape, mostly depicting a location on the estate of the nobility he portrayed, and thereby becoming the founder of a new version of arcadia in the dispassionate English style. In 1759 he moved to the fashionable resort of Bath, where, inundated with portrait commissions, he developed his style further by studying van Dyck, whose work could be seen in many country houses around Bath. In 1774 he removed to London where as portrait-painter he had to vie with Reynolds and his pupils. He became increasingly interested in lighting effects, as popularised by experiments carried out by the theatrical decorator Loutherbourgh. Gainsborough succeeded in becoming the favoured portraitist of the royal family. In 1782 he painted in Windsor a series of oval portraits of the royal couple and their thirteen children.

After some dispute he retired from the Royal Academy, of which he had been a founder member in 1768, and in the 1780s he began to arrange summer exhibitions at his private house. His final creative years are marked by a sensitive, poetic style and ethereal coloration. His free compositions, or fancy pictures as he called them, date from this time. In these Gainsborough surpassed his exemplar Murillo, sensitively exploring the theme of this childlike and rustic genre in an old-masterly brown-toned tenebrism. Gainsborough was a pioneer in landscape painting. Apart from his extremely personal style of portraiture and a short-lived fashion of imitating his *Fancy pictures*, he had an important influence on 19th century landscape painting.

A comparison of this double portrait with the earlier double portrait of *Mr and Mrs Andrews* is tempting: once again, we see two full-figure portraits in an outdoor setting. Yet even in the attitude of the couple towards each other, we already sense that there is a marked difference from his earlier work. The disinterested and cool juxtaposition has been replaced by an attitude of natural intimacy, and in place of the rather stiff immobility we see a light and elegant step. Lightness also determines the atmosphere with its gentle morning light that no longer lies on the surface, but in all of the colours, creating a sense of weightlessness. Foliage, fabrics, hair, the feathers on Elizabeth's hat, the fur of the dog – everything seems to consist of the same airy and light material. The two figures are not standing against a landscape background, but, in spite of their elegant clothing, seem to be integrated into it.

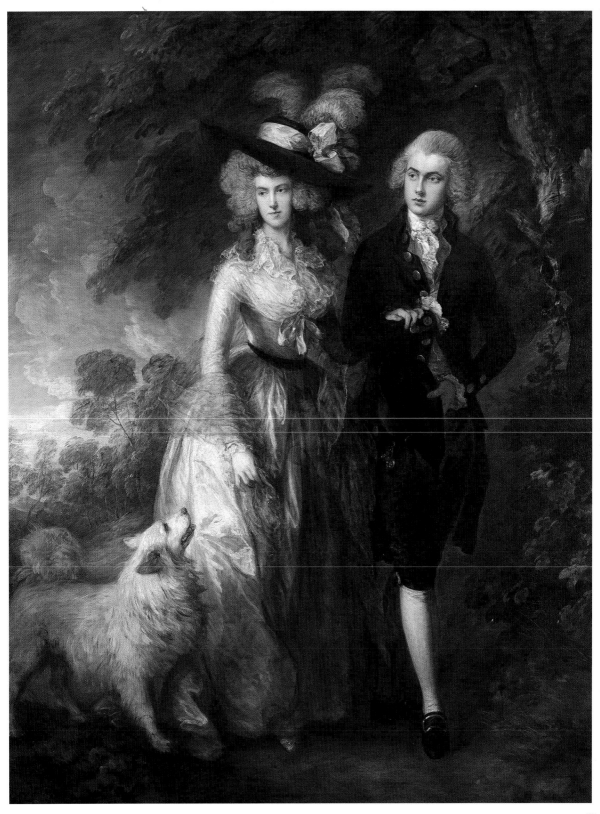

The Blind singer

Oil on canvas, 93 x 145 cm
Madrid, Museo Nacional del Prado

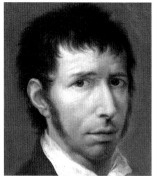

b. 1746 Zaragoza
d. 1793 Aranjuez

Like his brother Manuel, Ramón was eclipsed by his brother Francisco who, not least because he was Goya's brother-in-law, found a place in the history of art. Ramón accompanied his brother Francisco to Madrid in 1763, where he worked in an artistic climate dictated both by the late Baroque and by Classicism, embodied by the old Tiepolo and the increasingly influential arbiter of taste, Mengs. Ramón seems to have been less clearly associated with a particular school than his brother. For example, the prevailing influence of Classicism shows in the jointly executed frescos in Zaragoza cathedral, while in his portraits, but especially in his etchings which he carried out to his own design or after those of his brother or of older masters, the technique and picturesque gracefulness of Tiepolo are still detectable.

The blind man is sitting on a grassy knoll in a once smart but now ragged suit of brightest blue with a yellowish-brown cloak draped over his shoulders and the hurdy-gurdy on his lap. A little further down the slope, dressed in rags of grey, stands his young companion, playing on the castanets; a dog, prancing on its hind legs, is looking up at him. Bayeu shows a scene of beggars in a genre of poverty that has a long tradition in Spain. Yet this painting shows poverty and humility only in its objects.

The composition itself is diametrically opposed to the content: the bright blue of the clothing corresponds with the bright blue of the sky. The face of the singer – the face of a martyr and a poet – is solemnly illuminated by a warm glow and the contours of his figure are sharply and clearly outlined against the background. The vibrant green of the grass, the royal blue of the clothing, the flash of a brilliant red waistcoat all combine to create a magnificently elegant sense of harmony. Because the colour of the sky is linked with that of the beggar's costume, it elevates his figure to the level of great and memorable. The handling of colour, the clarity of composition turn the figure of the blind singer into a monument. The Neoclassicist stylistic techniques present their power to monumentalize a "lowly" scene.

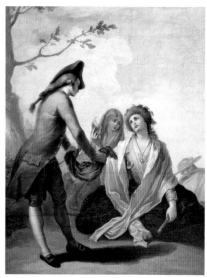

Rural Homage, undated

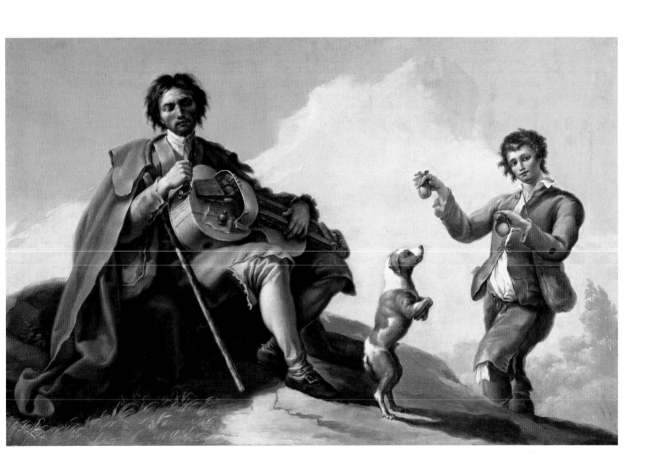

goethe in the roman campagna

Oil on canvas, 164 x 206 cm
Frankfurt am Main, Städel Museum

b. 1751 Haina (Hesse)
d. 1829 Eutin

Tischbein belonged to an artistic family branching out in all directions, and in whose circle he received early instruction. After studying under his uncle Johann Heinrich Tischbein the Elder at Kassel, another uncle, Johann Jacob Tischbein, took over, with whom he worked in Hamburg and Holland. From 1777 to 1779 he worked as a portrait painter in Bremen and Berlin. He then went to Italy, remaining there for almost twenty years. His friendship with Goethe produced the well-known portrait *Goethe in the Roman Campagna*, which he completed in Rome in 1787. In 1789 he was appointed director of the Accademia di Belle Arti in Naples. After returning home and settling in Hamburg in 1801, he was called seven years later to the court of the Duke of Oldenburg, at whose court in Eutin he worked until his death.

In a letter to Lavater dated 9 December 1786, Tischbein writes of this portrait: " … on the ruins that have witnessed such great deeds, a mortal man also appears great, and it is as though we knew him better." He portrays Goethe in classical pose, reclining on the fragment of an obelisk behind which there is an antique relief, an Ionic capital and, in the distance of the sweeping Campagna, the ruins of ancient aqueducts and the tomb of Cecilia Metella. These monuments are components drawn from the repertoire of the educated individual, thereby documenting his awareness of style. Archaeological and historic ob-

jectivity are blended with a sensitivity that transforms the quotations from antiquity into bearers of atmosphere.

The background of fragments highlights the wholeness, or integrity, of the sitter's personality, and the atmosphere of transience reflects a sense of vitality which need not be emphasized by action, for it is mediated by presence and determination alone. The literalness with which the concept has been illustrated is both the strength and the weakness of this painting. It reduces the depth of significance and has something compilatory, yet at the same time these very features are a compelling expression of the *zeitgeist* in an era that has begun to pay homage to a new cult of genius.

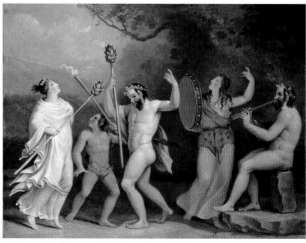

Dance of the Fauns and the Maenads, undated

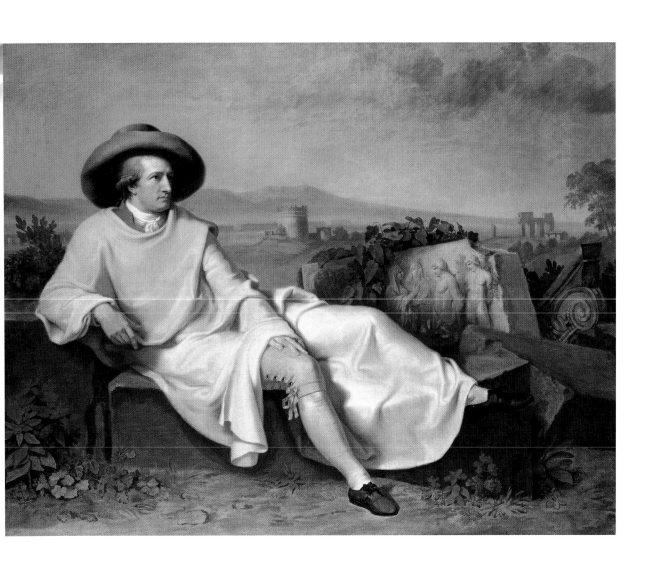

Portrait of Madame de Staël as Corinne on Cape Misenum

Oil on canvas, 140 x 118 cm
Geneva, Musée d'Art et d'Histoire

b. 1755 Paris
d. 1842 Paris

Vigée-Lebrun received early training from her father, a painter in pastels. Other teachers and those helpful in her career were Doyen, Vernet, Davesne and Briard. She also copied the old masters, particularly Dutch art. She soon became a celebrated portrait painter and was appointed court painter to Marie-Antoinette. She became a member of the Academy in 1783. She had to leave France in 1789 because of her court connections. From that time she travelled widely, visiting Vienna, Dresden, Berlin, London, St Petersburg and Switzerland, and was inundated with academic honours and commissions. Her emotional, idealising portraits of women and children, which were often criticised for their sentimental touches, were representative of an international style of portraiture already in transition; the characteristics come out more fully in her many self-portraits.

Madame de Staël, daughter of the French minister of finance, Jacques Necker, achieved fame on the basis of her turbulent lifestyle and two literary works: *De l'Allemagne* (1810), a portrait of Germany, its customs, literature and philosophy, and her novel *Corinne ou l'Italie* (1807). In this work based on her travels in Italy in the company of August Wilhelm Schlegel, after Napoleon had exiled her from Paris, she records her impressions of Italy in glowing tones through the mouthpiece of the fictitious Italian poetess Corinne. Vigée-Lebrun portrays her in the role of Corinne wearing an antique robe, with a lyre on her lap, as a female Orpheus. Behind this figure there is a cliff crowned by a classical monopteros, and a sweeping landscape that fades into the distance with gentle, green hills and blue mountain peaks. The concept of the classical and the romantic which Madame de Staël was first to use in its present sense, are echoed in these two landscape types. The flawless idealization that marks so many of this artist's works is countered here by the powerful vitality of the face: a mature, confident and energetic woman of astute intellect who is by no means identical with the role of glowing and effusive rapture.

The Genius of Alexander I, undated

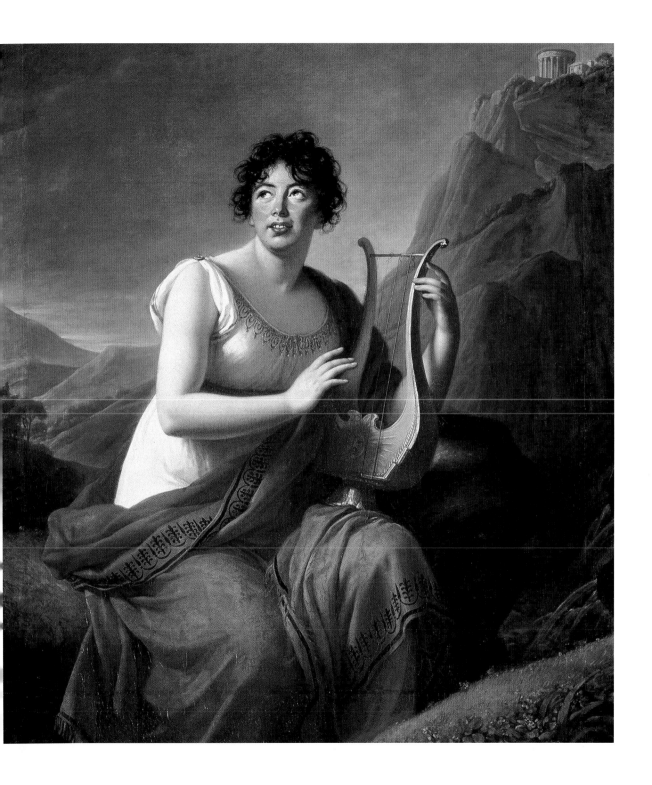

тhe вurial of the sardine (carnival scene)

Oil on panel, 82.5 x 62 cm
Madrid, Museo de la Real Academia de San Fernando

**b. 1746 Fuendetodos
(near Zaragoza)
d. 1828 Bordeaux**

Goya was trained in Saragossa by José Luzan, a pupil of Giordano and Solimena, before going to Madrid. There he entered the studio of Francisco Bayeu, his future brother-in-law, who worked under Mengs at the court of Charles III. After visiting Italy in 1770/71, Goya was asked to provide designs for the royal tapestry works. In 1780 he became a member of the Real Academia de San Fernando, later to become its deputy prinicpal and then principal. Having carried out court commissions since 1781, he was appointed as a court painter in 1786, painter to the royal chamber in 1789, and principal court painter in 1799.

Goya started painting in the Spanish version of the Rococo manner, intermingled with French and Italian elements, but from 1792 his style changed drastically. During that year he became deaf as a result of a severe illness. In a series of uncommissioned paintings he created, under the mask of ordinary genre scenes, a world of terror and nightmare (*The Burial of the Sardine*, ill. p. 399; *Procession of the Flagellants*; the *Mad-House*; the *Session of the Inquisition* – all Madrid, Academia de San Fernando). During the same period he produced *Los Caprichos*, consisting of 80 etchings (published 1799) to "scourge human vices and errors", as he wrote. With his *black paintings* of the Quinta del Sordo (Madrid, Prado) he reached the pitch of his portrayal of the negative and unaccountable in human existence. Under the pressure of the Restoration Goya left Spain and emigrated to Bordeaux. The deeply questionable in human nature, which is also expressed in Goya's portraits, did not find full recognition until the 20th century.

In a preliminary study for this painting, there are monks in the place of the women in their light-coloured dresses, and the banner bears the inscription *mortus* ("dead"). An X-ray photograph has revealed this word beneath the grinning mask that Goya painted. It is clear that, in both cases, the message was the same, though the preliminary study actually indicates its origins. It is the medieval game of the world turned upside down in which the rights and customs of the Church are perverted – with its permission – to utter anarchy, only to be followed all the more faithfully once order has been restored. In Spain at the time of the Inquisition, Goya's monks were eradicated from the composition, and the laconic clarity of the word *mortus* was replaced by a grotesquely grinning face. Its expression is now truly a banner, flying over a scene of uncanny happenings: an abyss of apocalyptic mania in which merriment is distorted to the point of menace. We are confronted with the image of a final, frenzied celebration in the face of death. Military men amongst the beggars, women and children are metaphors of order gone awry, order beyond all hope of restitution, subverted into the crazed desperation the anonymous masses hidden behind their masks.

"тhe sleep of reason produces monsters."

Francisco de Goya

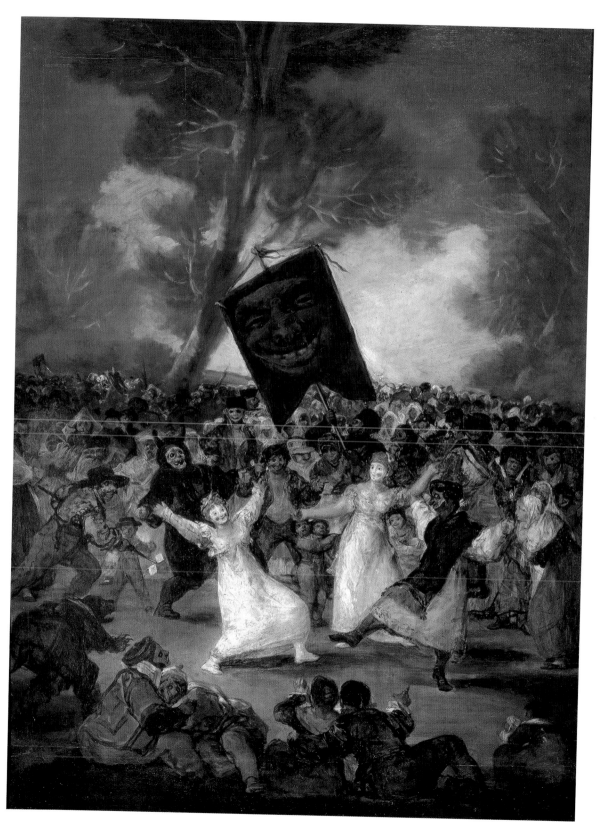

Portrait of
Lady Elizabeth conyngham

Oil on canvas, 91 x 71 cm
Lisbon, Museu Calouste Gulbenkian

b. 1769 Bristol
d. 1830 London

Thomas Lawrence was the 14th of sixteen children of a customs officer and later publican. An early fondness of acting and drawing drew attention to the child prodigy. When only ten he drew portraits of fifty prominent Oxford personalities. He was given some instruction sin pastel and oil-painting, but was largely self-taught, studying private art collections. In 1789 he introduced himself with the full-length *Portrait of Lady Cremorne* (Bristol, City Art Gallery) at the Royal Academy. He was a great admirer of Reynolds, and in effect became his successor on his death. Lawrence's acting talent showed itself in the way he posed and presented his sitters. In 1792 he became principal painter to the king, two years later a member and in 1820 president of the Royal Academy. He received his peerage in 1815, the same year he was asked to paint the leading personalities at the Congress of Vienna. His influence on Victorian portrait painting was fundamental.

In this painting, Lawrence shows how an individual portrait of little Master Ainslie can become a decorative *mise en scène* of the concept of perfect beauty. In this portrait, Lawrence proves his mastery in the art of showing beauty in its best light. The contrast of brilliant dark hair and pale skin, further heightened by the transparency of the dress, the strong red of the lips echoed only in the red drapery around her hips: all these show the hand of a virtuoso portraitist. Yet Lawrence has more to offer than the mere technical virtuosity of an established portraitist. If we recall the portraits by Gainsborough set against a landscape background, we quickly realize what is new and different about this portrait. Not only does it not show the sitter at full length, but it does not interact in any way with nature or even seem part of it.

Nature is merely the backdrop for a carefully rehearsed performance. Although the lady is just putting the tuning key to her harp, the picture is almost static. The scattered accents of colour, such as red, seem to act as a counterpoint to her balanced pose. The harp and part of the stone socle may be intended as bearers of elegiac atmosphere, but first and foremost they are stabilizing compositional elements. "Sentimentality" and Neoclassicism are found hand in hand here. A clear and stringent compositional architecture is hidden behind an air of dreamy softness. The concept of the experienced portraitist is cloaked in the guise of chance inspiration.

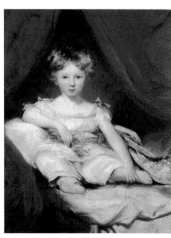

Portrait of Master Ainslie, 1794

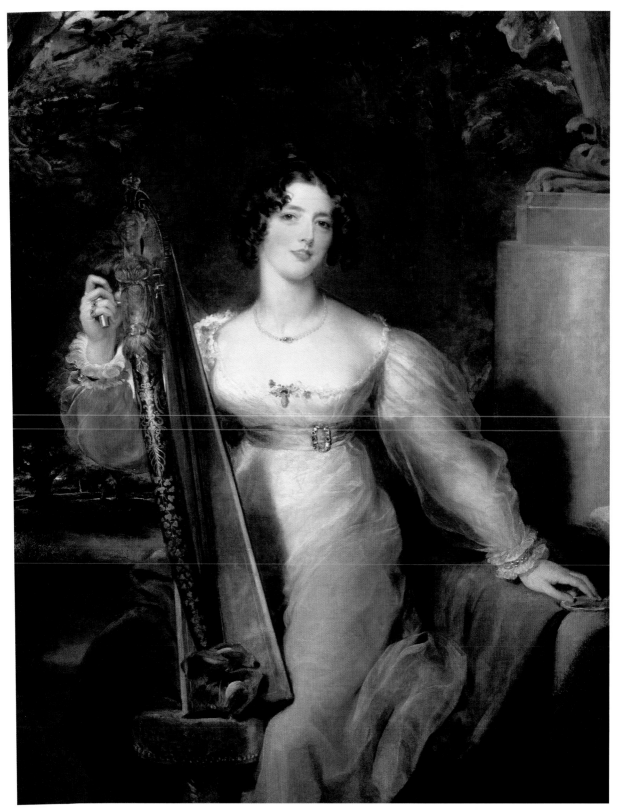

To stay informed about upcoming TASCHEN titles, please request our magazine at www.taschen.com/magazine or write to TASCHEN America, 6671 Sunset Boulevard, Suite 1508, USA-Los Angeles, CA 90028, contact-us@taschen.com, Fax: +1-323-463.4442. We will be happy to send you a free copy of our magazine which is filled with information about all of our books.

Project coordination: Juliane Steinbrecher, Cologne
Design: Sense/Net, Andy Disl und Birgit Reber, Cologne
Translation: Karen Williams, Rennes-le-Château
Cover design: Claudia Frey, Cologne
Production: Martina Ciborowius, Cologne

Printed in Germany
ISBN 13: 978-3-8228-5306-1
ISBN 10: 3-8228-5306-2